This book is dedicated to our two dogs who we loved
and lost to cancer, Carla Lou, our four-legged founder and
Lexi Doodle, our Lab/Shepherd mix, and in
loving memory of Howie Sazzle.

We also dedicate this book to the memory of Dianna Williams,
one of our greatest advocates who volunteered in
Kansas & Missouri on our behalf. We miss her every day.

We are their voice. Let's make them proud!

This edition first published in hardcover in the United States in 2014 by
The Overlook Press, Peter Mayer Publishers, Inc.

141 Wooster Street
New York, NY 10012
www.overlookpress.com
For bulk and special sales, please contact sales@overlookny.com,
or write us at the above address

Cataloging-in-Publication Data is available from the Library of Congress

Book design by Anthony Morais

Manufactured in the United States of America
ISBN: 978-1-4683-0863-1

♥ little darling's
PINUPS for
PITBULLS

A CELEBRATION OF AMERICA'S MOST LOVABLE DOGS

DEIRDRE FRANKLIN

THE OVERLOOK PRESS
NEW YORK, NY

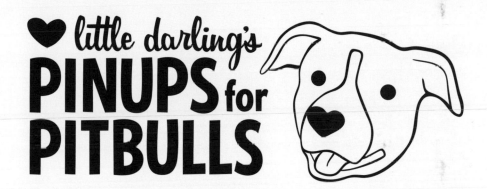

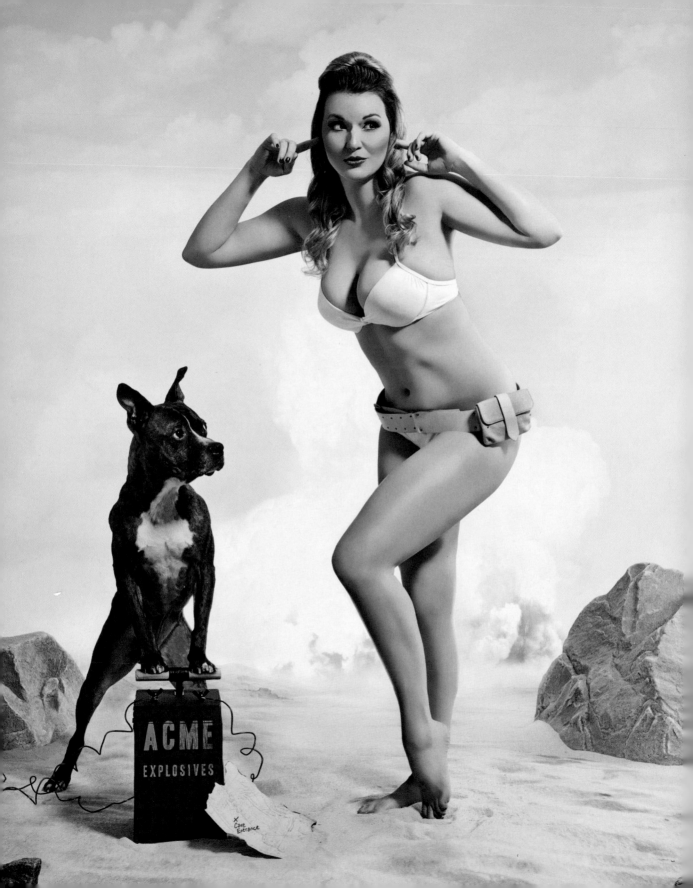

WHO WE ARE

Pinups for Pitbulls is one of the only—if not *the* only—education focused canine advocacy groups that endeavors to reach a broad audience with out-of-the-box, non-traditional approaches. We are a family of advocates working to protect our canine family members and their relatives. With an ever-expanding reach inside and outside of the United States, we are working to build an educated army of advocates to protect cities, families, and their chosen companion animals from harm's way.

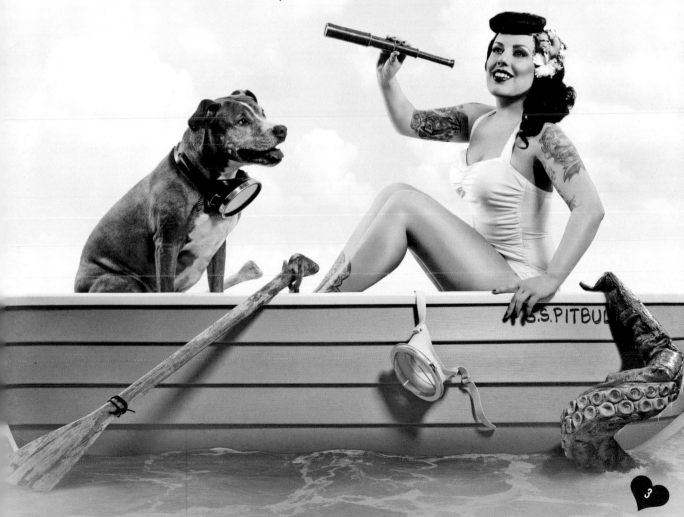

3

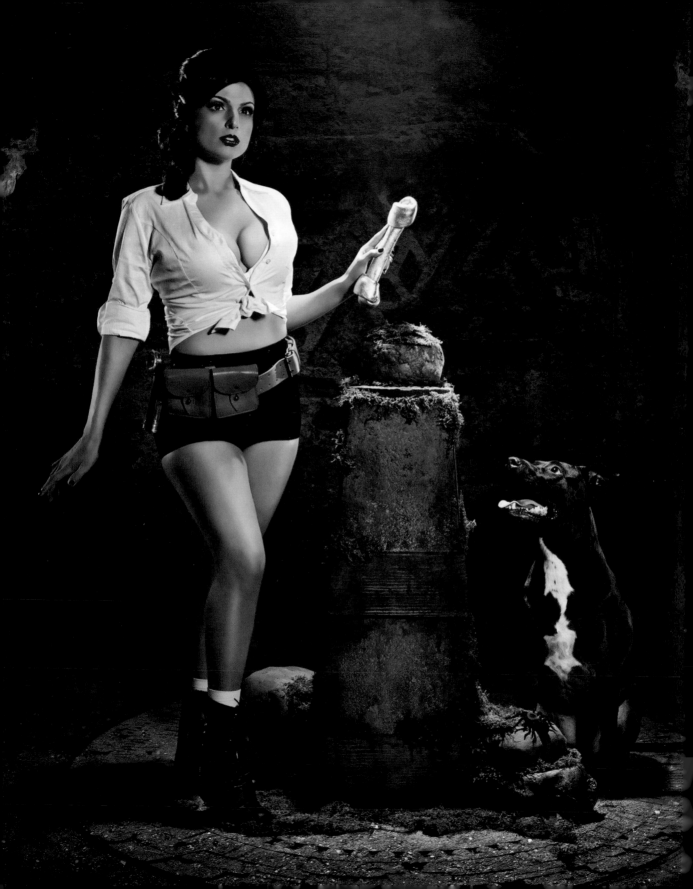

A common misunderstanding propagated by the media is that animal advocates are not on the side of public safety. That is simply not true. No one wants to see a child or animal suffer. We, and others like us, work to keep both children and animals safe through the enforcement of existing laws—especially leash laws. We do this through our booth presence at comic book conventions and tattoo expos, hosting special events, fundraising with other grassroots organizations, and by staying open to other non-traditional opportunities in our community.

Every year, we put out a calendar featuring a dozen beautiful women posing alongside their beloved four-legged friends. As you flip through these pages, we hope that you will notice the diversity of dogs gracing the spread. Most of the dogs in this book are not purebred; they are simply shelter mixes or varying crossbreeds. These are the dogs that we have chosen as members of our family.

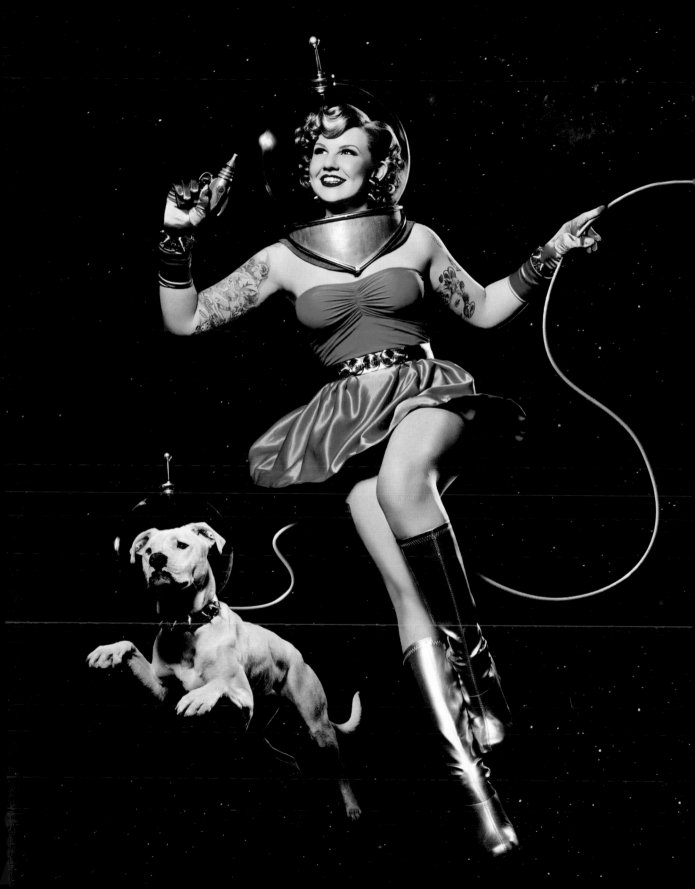

WHY PINUPS?

Who doesn't love to look at beautiful women paired with adorable pups? Pin-up girls attract all kinds of people from many different backgrounds. In creating our annual calendar, we have been able to reach broad audiences both nationally and internationally. Since we started, we have been interviewed by NPR and the Associated Press, among other outlets. We have even found ourselves on Animal Planet on more than one occasion.

Some people believe our success is due only to a "sex sells" marketing plan, but it is so much more than that. When someone walks up to our booth and asks, "Why Pinups?", my eyes light up. I tell them this: The ladies in these images are not professional models. Rather, they are animal advocates in their communities and for our organization. We transform them into pin-up girls in a professional studio so that we can grab people's attention and then provide them with the facts about laws affecting our family members—all with a smile!

Most of the time, people who stop by our booth stay engaged and we are able to clear up any misconceptions they may have about pit bulls. One elderly woman walked past our booth at a tattoo convention and read that we are advocating for these companion animals on one of our banners. She stopped in her tracks, looked up at me and asked, "Pit bulls can be companion animals? I never knew! I thought they were only used for fighting." I patiently explained a bit about the history of the breed and the mischaracterization rampant in the media these days. Afterward, she was a convert. "I can't wait to tell everyone I know!" she exclaimed. It is moments like this that make it all come together.

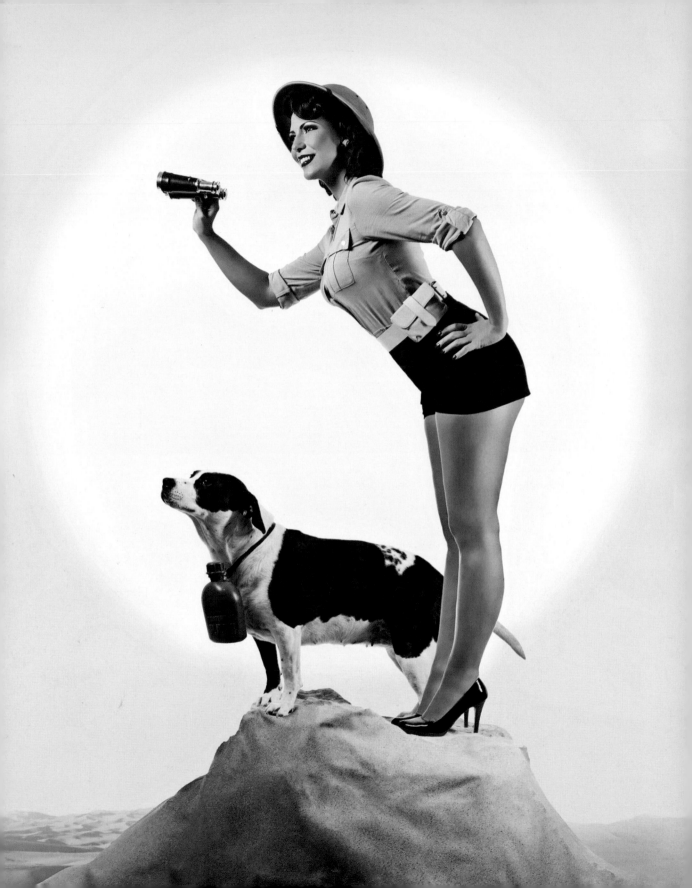

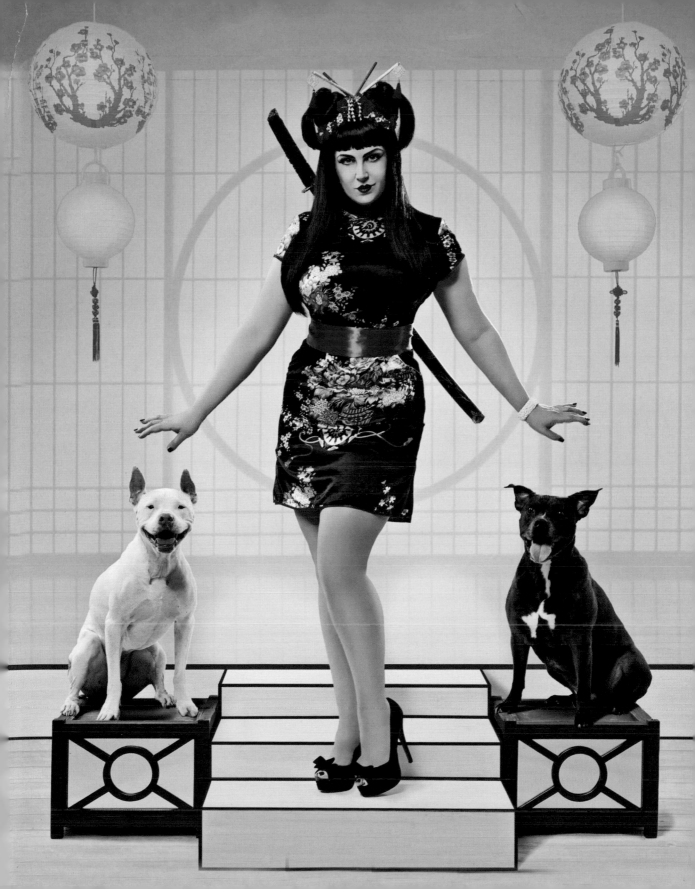

So why pin-ups then? Pin-up culture has been around since the late nineteenth century and is embedded in American culture. Using something that people of all ages can identify with—and pairing it with the fact that the American Pit Bull Terrier also became popular during this same era—has helped people to better identify with our cause. We often explain to people that the first American canine war hero was a pit bull–type. This is early American history that many people simply do not know. We get to tell people that nothing about these dogs has changed; it is only the *perception* of them that has changed. In forming Pinups for Pitbulls I hoped to restore the good reputation to these dogs so that they can enjoy safety from bans and euthanasia and be just what they are, companion dogs.

CARLA LOU: THE DOG THAT STARTED IT ALL

In the mid-1990s, I was volunteering at a local shelter in South Philadelphia. At the time, and until only recently, this shelter had what was known as a "kill pit bull" policy, which meant that while other breed types could stay as long as possible in their shelter, pit bulls would be destroyed. I was in my late teens at the time, and I wasn't sure if this policy was as firm as it sounded. Each week, I visited the shelter after work and would walk dogs up and down Lombard Street in order to help them avoid "kennel craze"—a breakdown for dogs that sit without any exercise or affection for long periods of time.

15

It was a small shelter, and I kept hoping that my dream dog—a Husky—would one day find its way through the shelter doors. On an especially slow day I found myself hanging out by the intake counter when a woman came in with a fawn-colored female pit bull. The dog seemed friendly, and it appeared as if she had weaned puppies recently. The lady who brought her in told the receptionist that she had found this dog roaming the city streets and wanted to be a Good Samaritan by bringing her to safety here at the shelter. The receptionist informed her that, unfortunately, if she were to leave this dog in their care, the dog would be euthanized immediately, just because she was a pit bull. This was the first time that I had actually seen a pit bull in the shelter. The woman told the receptionist that she already had dogs of her own and could not keep her, but instead of driving her to another shelter that might not harm the dog, the woman simply turned her back and left her there. I was asked to bring the dog back to a kennel to get her situated, which I did without protest. I set her up with food and water and a place to rest.

Watching the frightened look on this dog's face and the gentleness she showed when I cared for her, I knew this was no "vicious" dog. She was just born with a title that people feared. I couldn't just sit by and let this dog die. I petted her while I reassured her that I would do everything I could to get her out of there. Quickly walking to the front desk, I asked to take the dog home. I was stupefied when they told me that there was no way the dog was leaving, that it was their policy, and the final sentence for the newly arrived pup had already been passed.

I was sickened and scared for this dog and all of the dogs that had met such an unnecessarily cruel fate. I went back to the kennel, kissed the fawn dog, and assured her that I would figure this out. I rode my bicycle home as fast as I could in order to find a rescue that might be able to step in to save her. As you might remember, the nineties were the days of dial-up Internet; there was no such thing as Google, and finding a rescue was harder than you would think. But I was able to find one organization called Chako Pit Bull Rescue in College Station, Texas. I wrote an urgent email begging them to intervene in whatever capacity they could before it was too late.

To my surprise, they got back to me almost immediately. The founder of Chako, Dawn Capp, made calls to the shelter and was similarly shocked when they told her it was their policy to euthanize all "pit bulls"—which is really a catch-all term that could refer to any number of breeds—for "insurance" reasons. They outright refused to assist in the release of the dog no matter how hard Dawn pushed. It began to seem like a lost cause.

Later that day, Dawn called to let me know that the future was grim if not already over for this particular dog, but she also encouraged me to apply for one of the three other pit bulls that she had recently pulled from her local shelter. It had never occurred to me that I would want any dog other than a Husky at that point in my life, but I felt a strange compulsion to apply for a dog through Dawn.

The rescue required that any applicant looking to adopt one of their dogs must pull a police report on herself, so in Yardley, Pennsylvania where I grew up, I found myself at the police station requesting documentation to prove that I had never fought a dog or participated in other illicit activities. This small town police station found this request hilarious and asked why I needed it. When I told them I was trying to adopt a pit bull from Texas, they looked at me like I was crazy. A teenager from a quaint little town like Yardley—what would I want with that kind of dog? Even my own mother thought I was nuts.

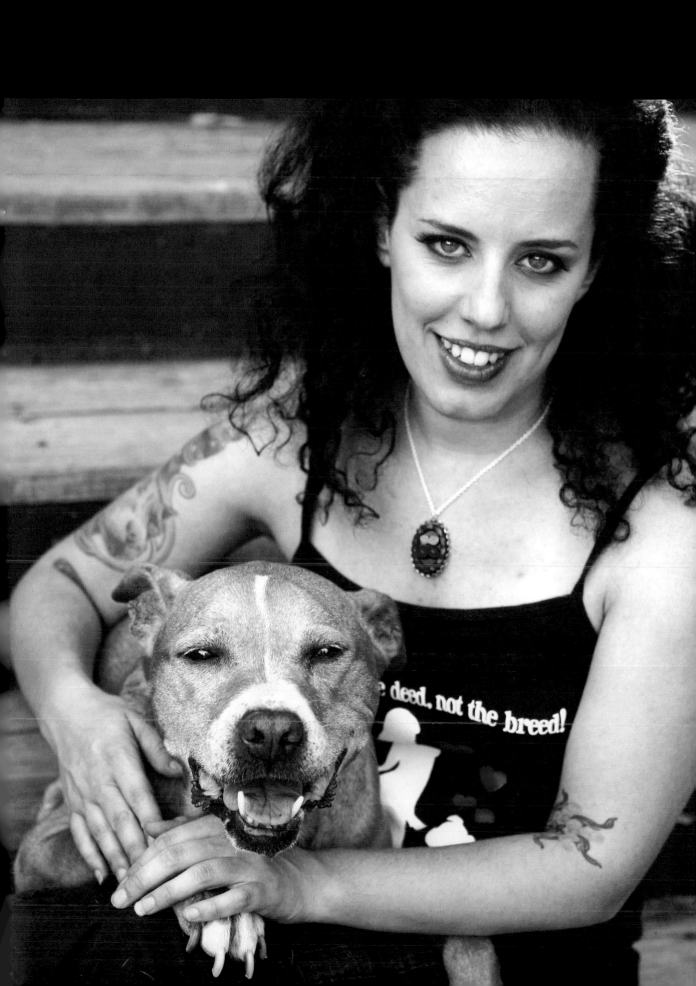

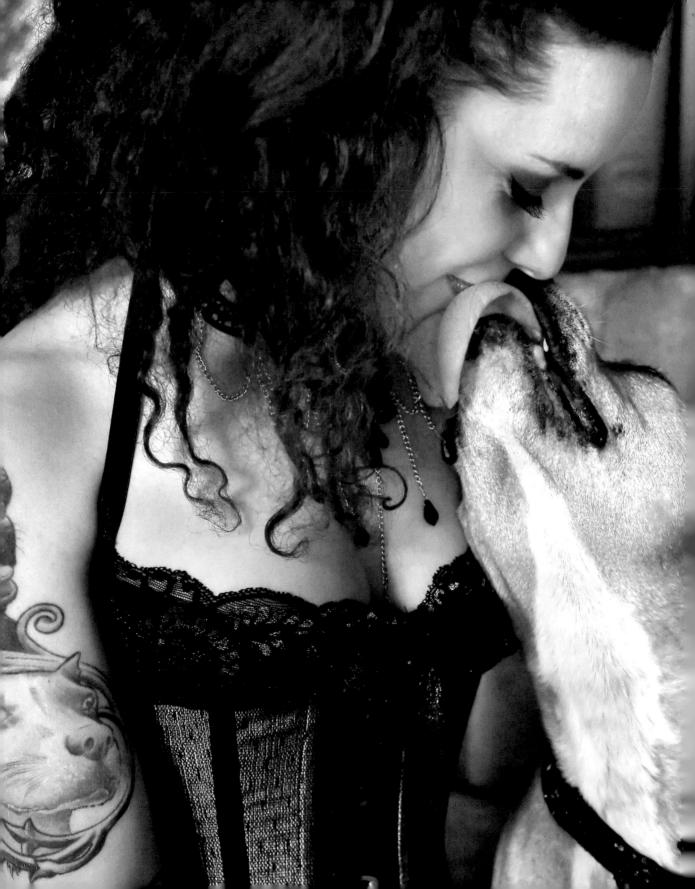

After about a month of background checks, paperwork, and application processes, I received a photograph of Carla Lou from Dawn on the evening prior to her flight. The image was dark and grainy. Carla looked like a gremlin next to the haystack in the barn where she was standing. She had mange and had recently survived being left for dead in someone's basement. It was alleged that her previous owners were going to use her to breed fighting dogs, but there is no proof of that. They moved out and after a week of not seeing the dog leave, a nosy neighbor thankfully called animal control to see if she was okay.

Waiting in the Newark Airport cargo area for Carla Lou to land, my stomach was tying itself in knots. What should I expect? What if the dog was not friendly? What if we did not like each other? Was that even possible?

Suddenly a forklift delivered her like cargo at my feet. I had a collar and leash ready to place on her when I opened the crate. What came next was entirely unexpected: Carla Lou dove out of the crate at my face with the full force of her 55-pound body, practically knocking me to the ground. She pushed her face against mine and lashed her tongue furiously across my cheek. It was love at first kiss.

Many years went by, and our bond grew stronger. We lived in my late grandmother's apartment in Queens for a while, but soon it became clear that New York wasn't for us. After a brief stint in Philadelphia, we eventually worked our way to the West Coast, where we were lucky enough to find an apartment in San Francisco that would allow "her kind" into the building. Our new neighborhood, Hayes Valley, was everything we had hoped for. Everywhere we went, Carla Lou was welcome. We rented movies together, went to North Beach for spaghetti dinners at outside cafes, visited bars, and, of course, went on regular walks through the parks. We were leading a charmed life.

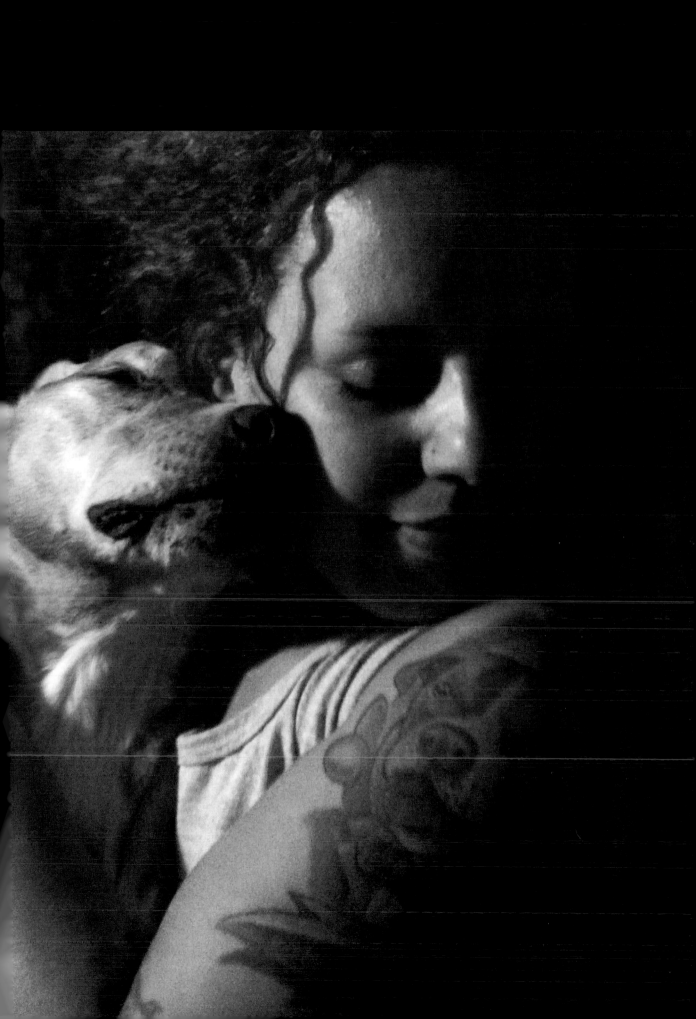

In the toughest of times, I relied on Carla Lou for so much. She taught me grace. She helped me learn that I was loveable and inspired me to be a voice for not only her kind, but for all animals. I never knew that a four-legged critter could be all of these things for me. She was like a little sage filled with wisdom, empowering those who were lucky enough to know her.

When people met her, even if they were afraid at first, she would look at them with her warm brown eyes and fill their hearts with love. She inspired me to start Pinups for Pitbulls because I wanted to protect not only her but her canine sisters and brothers, too. This is why Pinups for Pitbulls exists and grows each year. My job will not be complete until all dogs are understood to be innocent. The person at the other end of the leash, if there is even a leash, is responsible for their behavior and future.

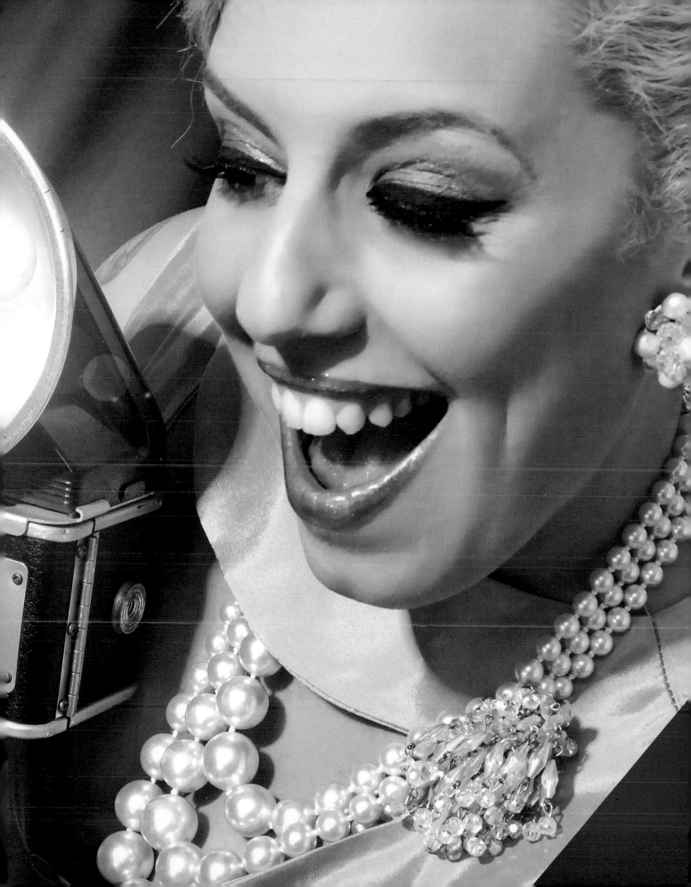

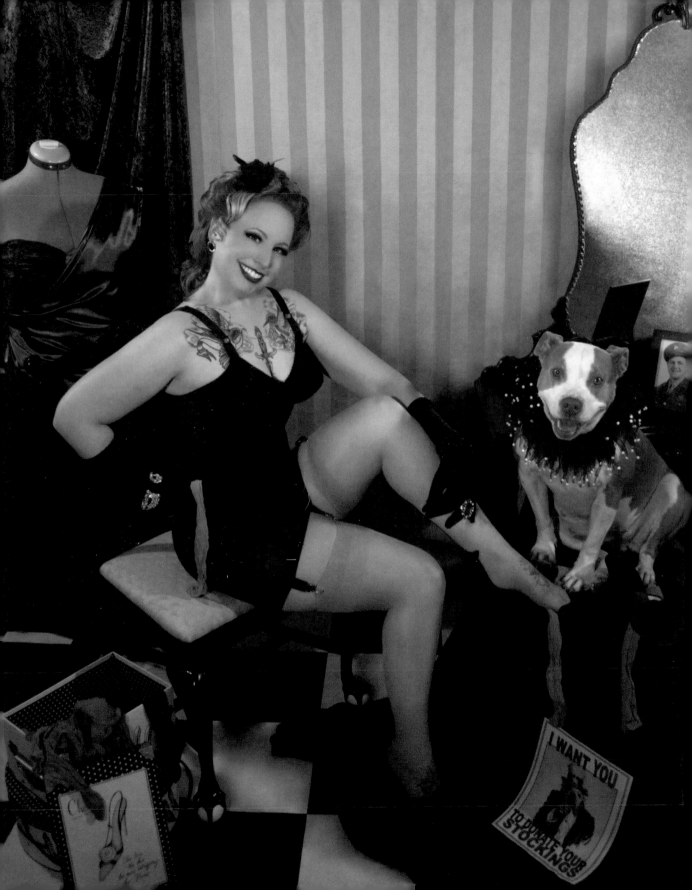

I WANT YOU
TO DONATE YOUR
STOCKINGS

THE EARLY YEARS ♥

At the time that I founded Pinups for Pitbulls, I was modeling regularly, performing as a burlesque artist, and working a day job at a non-profit. I had a wide fan base and the help of truly talented photographers, make-up artists, and hair stylists at my disposal. When I initially started modeling, it was primarily in the alternative genre. Dressed up as a doll or as a sultry modern pin-up, I enjoyed morphing into various characters in front of the camera. I found myself growing more and more confident while I was also building a network that would later become the foundation for the success of Pinups for Pitbulls. I had no idea at the time that this hobby of mine would become my future.

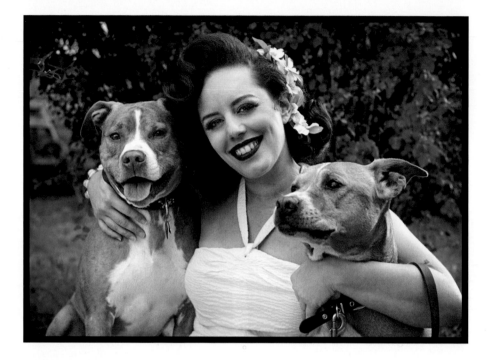

My modeling opportunities grew all over the United States through my Internet contacts and social media presence. As my confidence grew, I began wanting more than just still images and memories. I decided to try out at an event called the "Goddess of Burlesque" contest from a Philadelphia-based troupe known as Hellcat Girls Burlesque. It turned out that I was a natural. I performed for the crowd and found the art of the tease truly inspiring. I was quickly embraced by this all-female troupe and found a sisterhood with whom I wanted to grow. We began to tour from New York to D.C. at venues like the Palace of Wonders and even private high-end events in Philadelphia at places like the Trocadero, where the original burlesque performers of the past had once graced the stage.

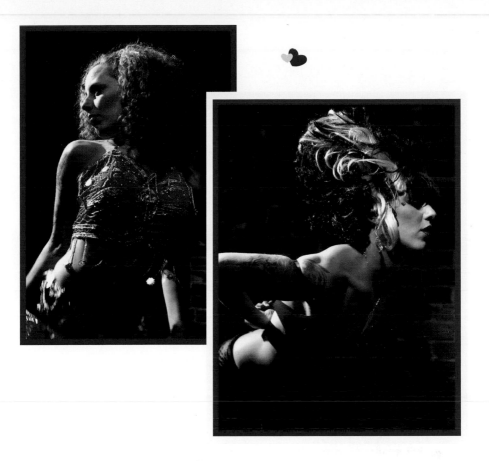

Burlesque inspired me to create and share my vision with the world. I was known as "Little Darling" in the burlesque community and had signature numbers performing as the Bride of Frankenstein, a sea monster/mermaid, and in classic fan dance routines as well. Performing brought me closer to different photography opportunities and allowed me to grow my portfolio for posters and promotion. With a growing fan base, I realized that my modeling and burlesque careers could be used to further a much needed shift in canine advocacy, especially for pit bull–type dogs.

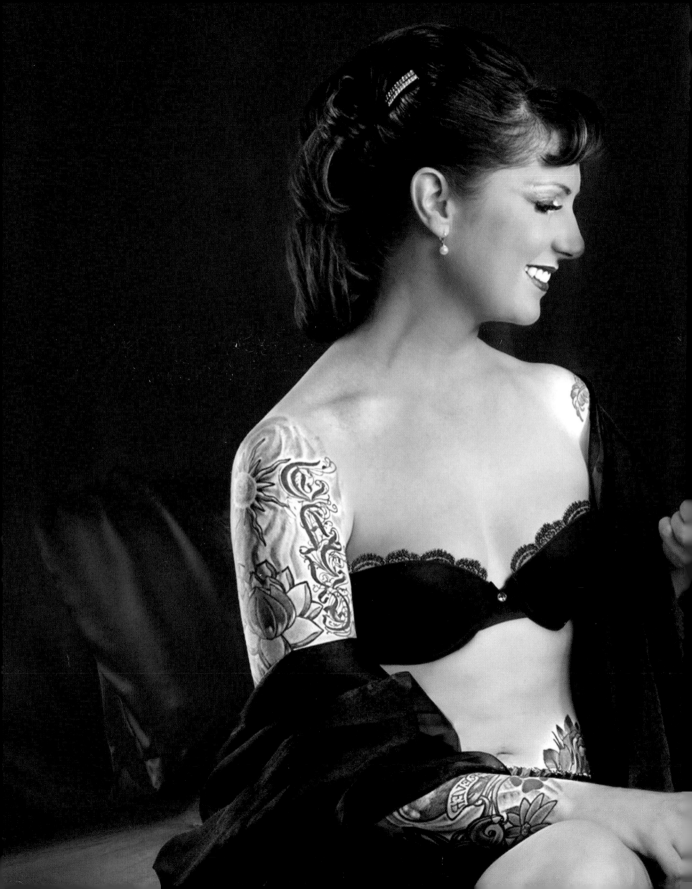

When I started Pinups for Pitbulls, I had no idea that all of these hobbies would lead to grassroots advocacy of this proportion. The people I was meeting all over the United States through online channels and at our performances or modeling shoots would later become the people that I tapped for assistance with calendar submissions and fundraising events. We hosted at least one hundred events involving burlesque, sideshow, live music, and, of course, Pinups for Pitbulls. When the Associated Press article came out, our story about how we were "stripping" stereotypes went viral.

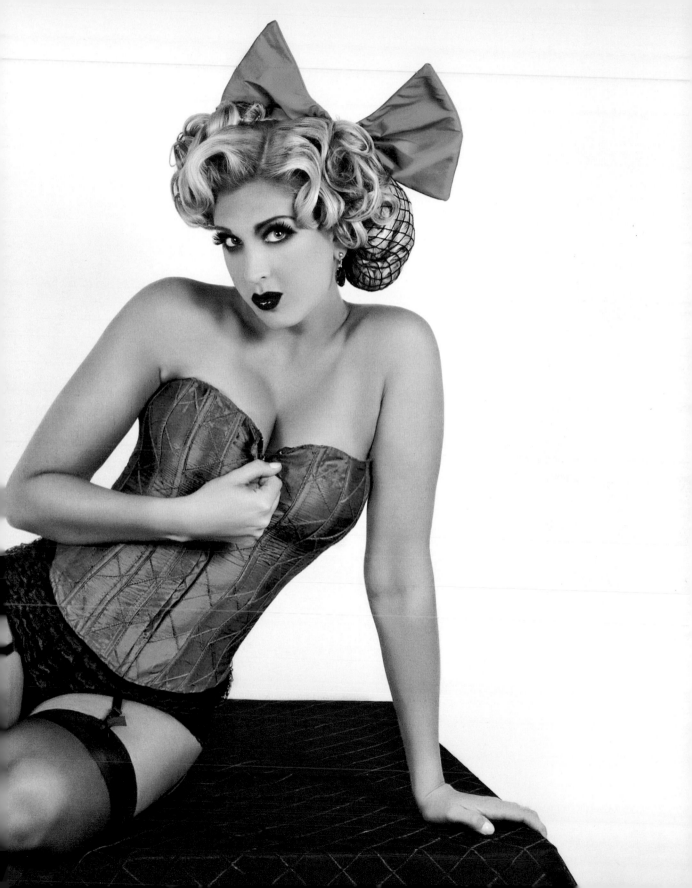

We find that working with other women is an amazing experience that is not to be taken lightly. Many people still believe that women cannot work well together. We are an organization that is breaking down that stereotype every day. We love our female counterparts and the passion and creativity that they bring to the mission. We even have many amazing male volunteers these days too!

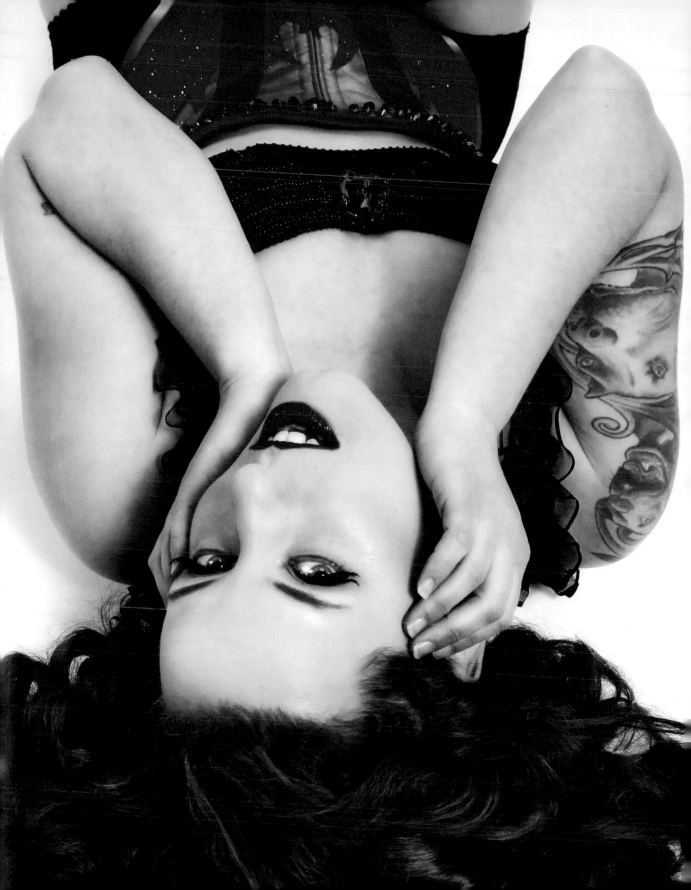

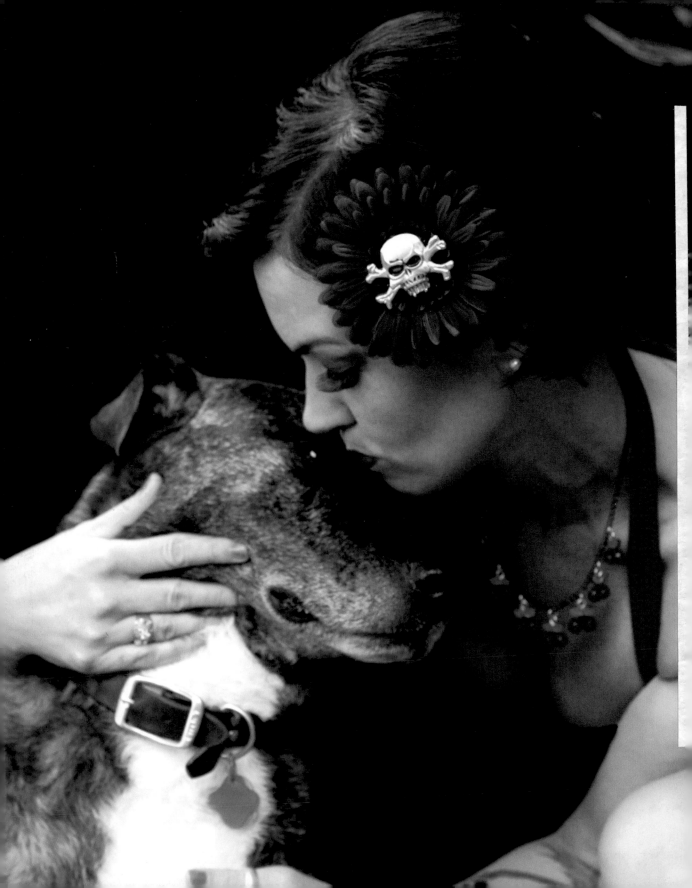

A defining moment for me and for our organization came when Hurricane Katrina hit New Orleans. I was transfixed as I watched the storm unfold on television. People stranded on rooftops, animals floating by on portions of fence; it all left me feeling desperate to do something beyond calling the toll-free hotline to make a donation. I wanted to get my hands dirty and be there on the ground. Even though I felt helpless, I logged onto MySpace and asked my friends to help me get there. In a matter of days, I was able to raise about $1,500 from strangers, friends, and family who believed in me and were grateful that I could go even if they could not.

I didn't know many people down South, but luckily my friend Kat offered to pick me up when I got to Louisiana. I had actually never met Kat and had only shared a love for dogs—specifically pit bulls—with her through online images. Kat picked me up and took me to the makeshift rescue location called Lamar-Dixon (predominantly a horse stable at the time) in Baton Rouge. When I arrived, I was surprised to see that it was

a fairly unorganized scene. People who were already there had been overworked and exhausted, forgoing their own health for the sake of the animals. We immediately went to work feeding and walking dogs, washing out kennels, and helping log any visible wounds so that the veterinary volunteers could tend to them as needed. I brought a white pit bull to the vet clinic that had smacked his tail so hard from gratitude that he needed medical attention. As we helped the dog with the damaged tail, a semi truck arrived with more animals to be received, logged, given treatment, and then sent to their new temporary living quarters. There was no Internet access and I began to see a huge logistical problem taking shape. We were housing hundreds if not thousands of family pets and the process of reuniting them with their people was going to be difficult without a database. We probably worked about fifteen hours straight the first day and then popped up our tent and passed out, with a deep ache in our hearts, knowing how many animals might never find their people again.

The next morning we stood outside of a weatherworn Winnebago awaiting orders so that we could go out and do search and rescue for the animals reported missing by their people. We waited from 7:30 AM in the hot sun until close to noon before we received our assignment. We packed Kat's car with as much dog and cat food and aluminum pans as we could fit. We were also provided with aerosol spray paint cans along with a list

about three inches thick of addresses to check for missing pets. We drove toward New Orleans, our hearts sinking as we saw the damaged Super-dome amid the desolation surrounding the empty highway.

We came upon a checkpoint where we had to give our mayoral approval forms to the police to be granted access to the city. The crow-bars that were handed out made us realize how hard it was going to be to free animals. We listened for animal cries as we went from ad-dress to address, opening doors and windows, and spraying on the outside walls what we found or did not find. We spent much more time break-ing in than we did finding live ani-mals. Many of the homes we entered had water marks up to ten feet on the

walls, with dry fish caked to them and muddy floors. Staring at the devastation, I could not help but wonder what it would be like for these families returning home, without their beloved pet and with nothing but ruin at every turn.

The only dogs we found were running loose since the fences were all knocked down. I saw so many pit bulls running free with all sorts of different breeds by their sides. We found a sweet little brindle puppy that could not have been more than six months old and were able to corral her into the only standing fence in what seemed like the entire city. We named her "Sweetie" and we fed, leashed, and snuggled her while we celebrated

that we could actually bring a dog back with us! We visited several homes, multiple apartment buildngs, and neighborhoods until night fell, and we headed back to Lamar-Dixon as per the Mayor's orders.

That night, after getting Sweetie settled in, we went to sleep at Kat's house and had our first showers since starting our rescue work over 48 hours earlier. We cried, reminisced, and shared our hope that we were able to help.

On the flight home, I was deeply troubled by the thought of all the pitbull–type dogs that filled the crates at Lamar-Dixon in comparison to other breed types or mixes. I knew I could do more for these dogs, and I wanted to do everything that I could.

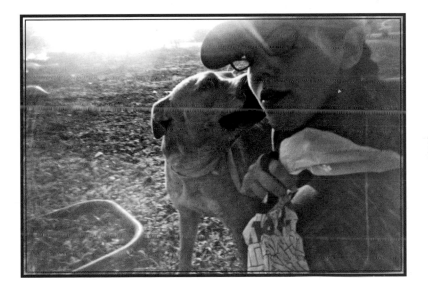

" I feel very privileged to be one of the few who has been with Pinups for Pitbulls from its inception. I remember Deirdre leaving for New Orleans and coming back full of passion that something needed to be done. I was there when one of our first events was setting up a folding table on the street in New Hope, Pennsylvania and asking passersby to buy our little calendar. I was there when the first online orders came through and we sat in Deirdre's living room eating pizza, watching bad reality TV, and hand addressing each and every envelope.

It's surreal sometimes to look back at where everything started and where we are now! Over 300,000 Facebook followers! Advocates, volunteers, and supporters from coast to coast! National events and speaking engagements! TV shows! And most importantly, thousands of dogs saved—taken off the streets, taken from high kill shelters, and placed into loving foster or forever homes. Incredible!

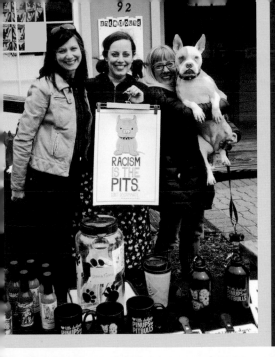

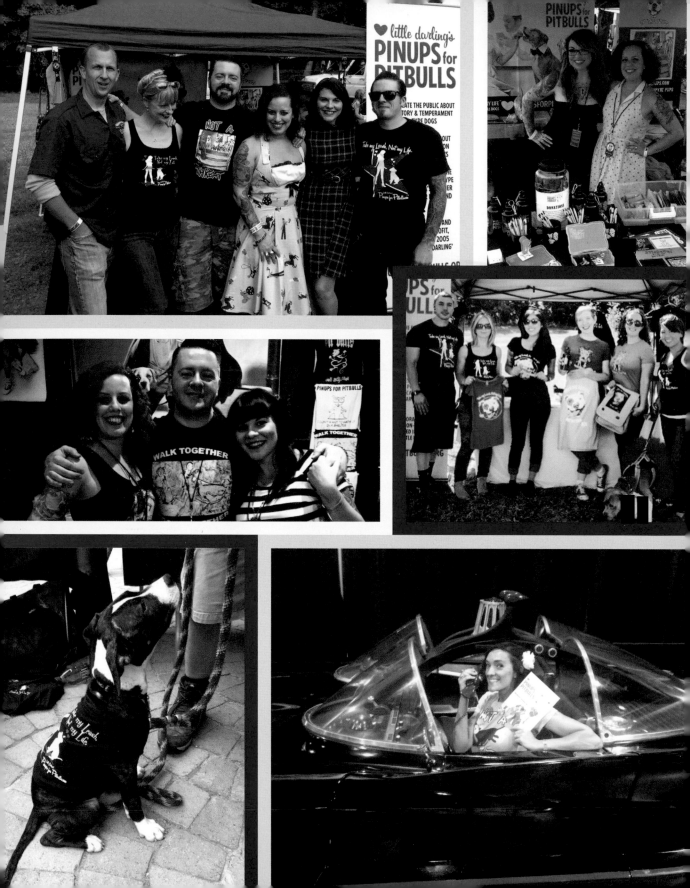

But what the public doesn't see is the impact that Pinups for Pitbulls has on its volunteers. We are more than just 'those girls that take pictures with dogs.' We are a family and community. We attend each others' weddings, celebrate children born, mourn pets lost, and provide an unbreakable support system stronger than anything else I've ever been a part of. What I've been blessed to witness over the last ten years are bonds, friendships, growth and unconditional love. I've seen volunteers come to us feeling frustrated and lost, looking to make a change in the world and in doing so they discover their own beauty and worth. And even when life changes take some of those people away from us, it's clear that they are leaving a different, better, stronger person.

Truly, none of this would be possible without that one certain person: the one who directs us, guides us, provides us all with clarity, grace, and calm (without even knowing she's doing it most of the time I bet!). As someone who has leaned on her many times over the past ten years, I know without a doubt I would not be the woman I am today without Deirdre in my life. And I know if you asked her, she would say none of it would have happened without the love she shared with Carla Lou. And so, as is fitting for what seems to be the main theme of my life—it always comes back to a dog!"

—RACHEL LOVE, Pinups for Pitbulls board member

little darling's

Pinups for Pitbulls

2007 calendar

photography, hair, & makeup by *bombshell pinups.net*
layout & design by serena falzini

founded by little darling of *pinupsforpitbulls.com*

2007

For our first calendar in 2007, the ultimate goal was to start at the grassroots level of fundraising and put something together that was cost effective enough to raise money and awareness simultaneously. I practically had to beg my friends and rescue colleagues to be a part of it since it was the first of its kind and I could not pay the models for their time. It was a learning process, but it also became the foundation for our future growth. A photographer known as "Bombshell Mandy" donated her time and talents to not only shoot the calendar but to do all of the hair and makeup as well. We featured quotes from various animal lovers and even sold ad space to help pay for the expense of printing. All of the proceeds from that calendar went to benefit local dog rescues. The calendar release party took place at an art gallery in Philadelphia, which would be my very first chance to tell the public about my mission.

2008

The following year was a bit of a hodge-podge as I searched for the identity of Pinups for Pitbulls. It mostly featured friends and other people who were somehow connected to the organization, many of whom were performers I had shared the burlesque stage with.

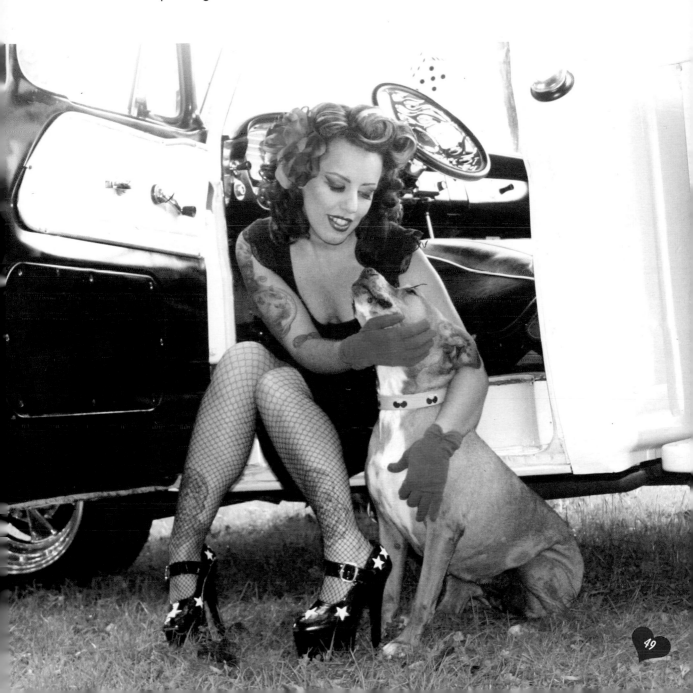

2009

It was in 2009 that we really found our footing. This was a special year since one of my favorite West Coast photographers lent her talent to shoot the cover for us, which featured Tiki Art from an artist in Southern California known as Tiki Ray. This was the first calendar year that we required a model application to have a chance to be featured, and we also asked different photographer friends to shoot the entire calendar. We worked with Tabatha Acosta of Cherry Blossoms Photography, Ivy Darling of Wandering Bohemian, and Shannon Brooke of Shannon Brooke Imagery. This new concept allowed us more creative influence and gave us the chance to direct the mission even further.

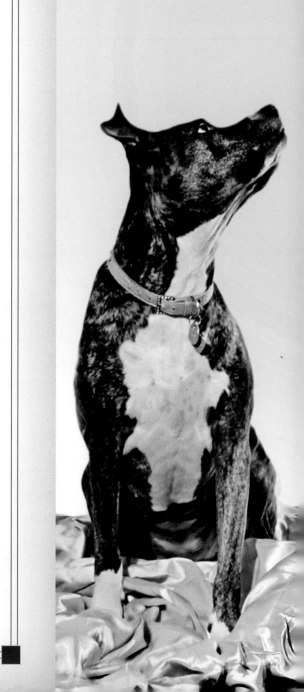

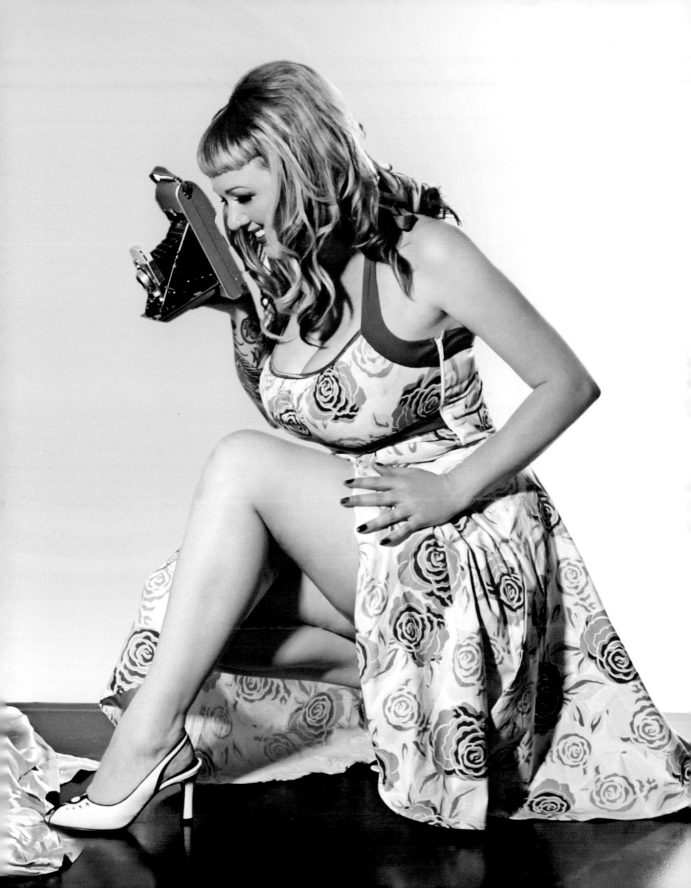

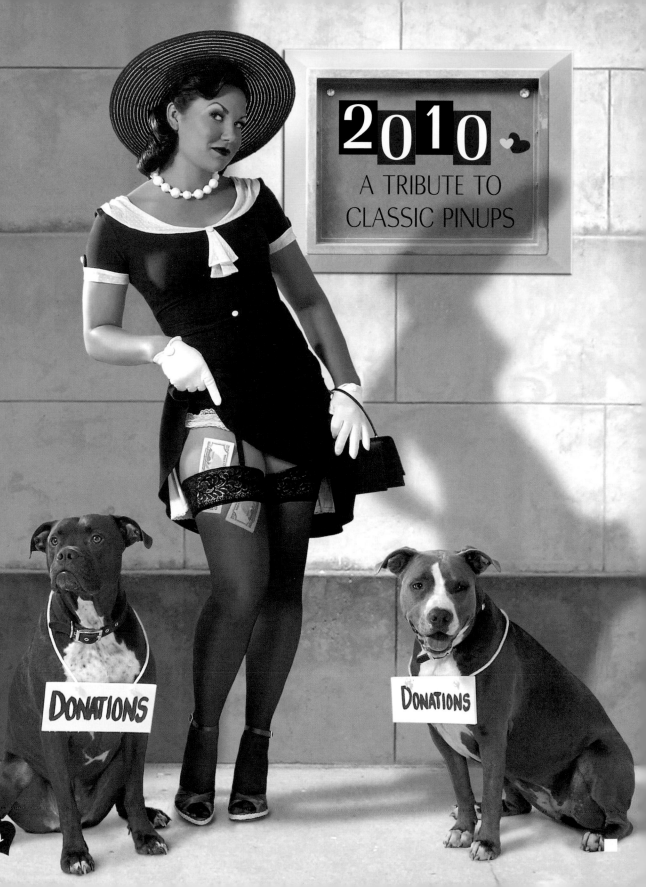

2010
A TRIBUTE TO
CLASSIC PINUPS

DONATIONS

DONATIONS

In 2010, we shot a tribute to classic pin-ups on the set of Animal Planet's television show *Pit Boss*. The shoot featured Shorty Rossi's (late) dog Geisha and I as we recreated a famous Gil Elvgren photo. Shannon Brooke once again lent her talent to our calendar, and this was the first year that we had open submissions for the actual finished product of a photo. We assigned a classic pin-up shot to each girl who chose to apply. This calendar featured not only beautiful ladies and pit bull dogs, but it also included a few small dogs, my (late) Lab/Shepherd mix, Lexi, our Harrier mix, Zoe—and a kitten! We had several adoptable dogs in this calendar that later found homes through our network.

MEMO:
JUDGE THE
DEED
NOT THE
BREED

ROYAL

53

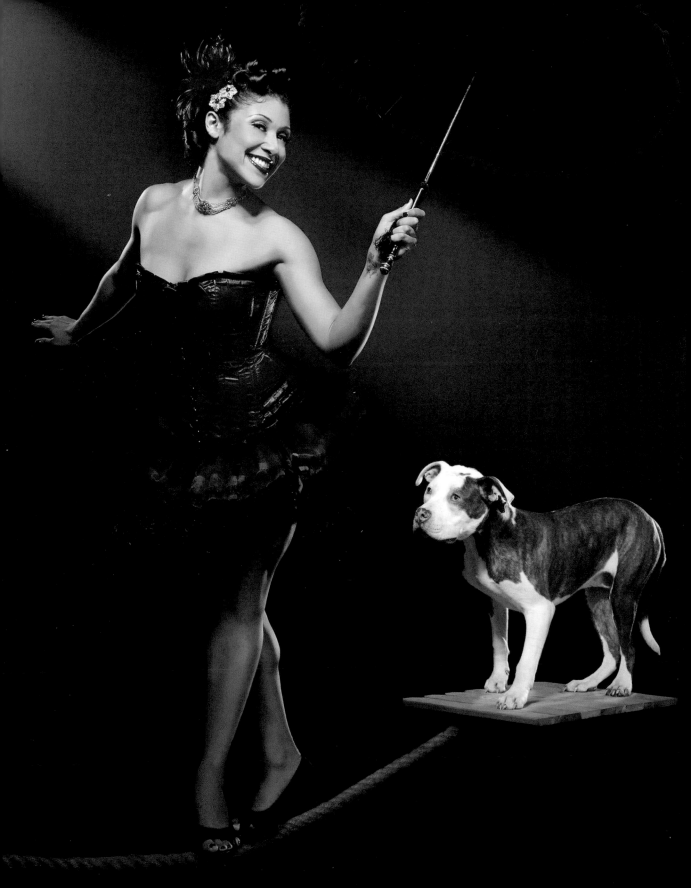

2011
A MEDIA CIRCUS

For 2011, once again we allowed the submitters to apply with a finished photograph for a chance to be featured in the calendar. As animal advocates, this was a chance to provide a vision of a cruelty-free circus. I have always loved vintage sideshow and circus artwork, and I wanted to find a way to share that love with our audience. In addition to the many dogs featured in this calendar year, we also had an Appaloosa horse with a beautiful pin-up sitting atop and her two dogs beside. This was the first year that photographer Celeste Giuliano shot the cover for us. Our working relationship was steadily growing and we hoped to one day have her shoot the entire calendar for us.

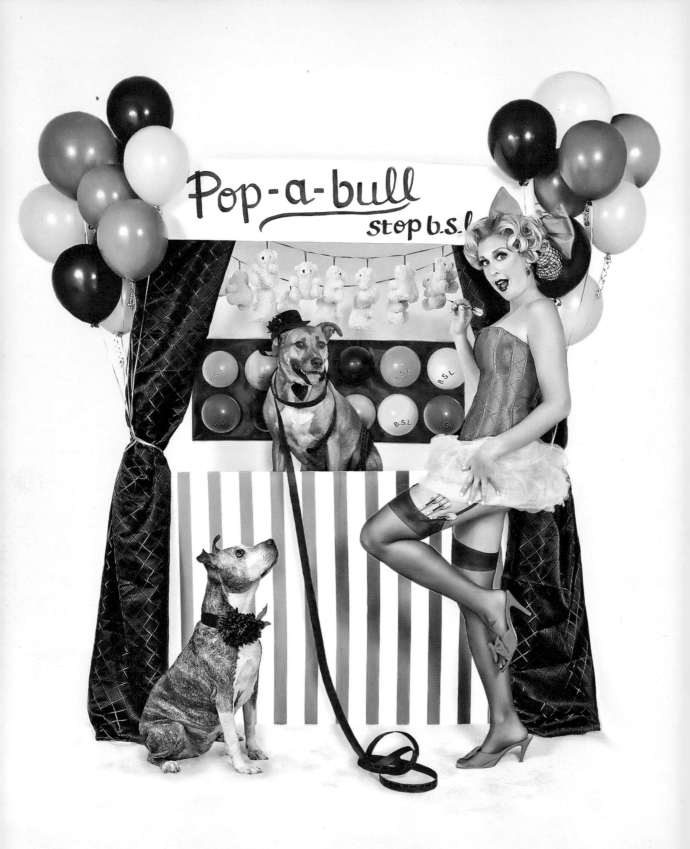

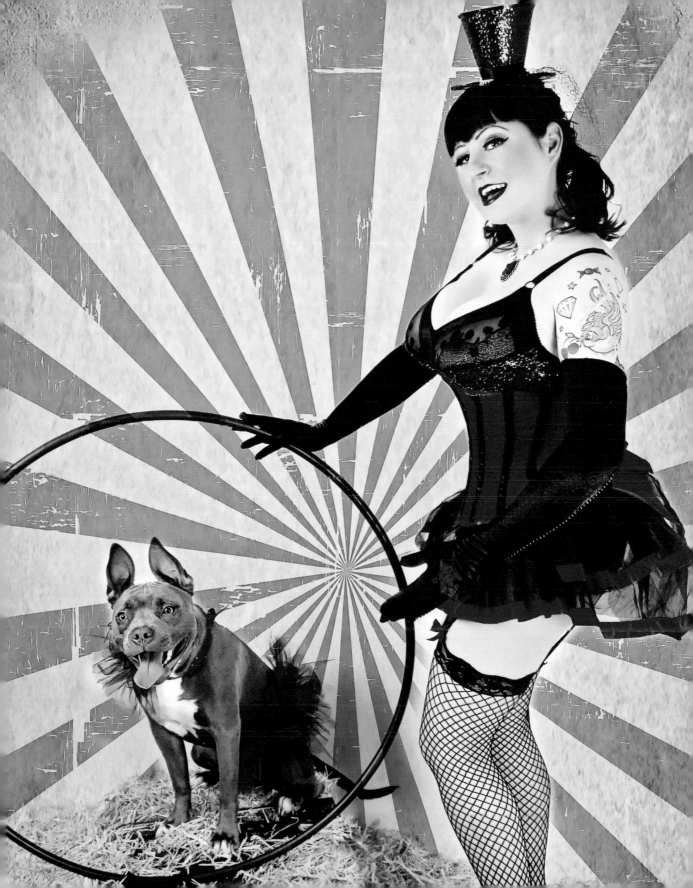

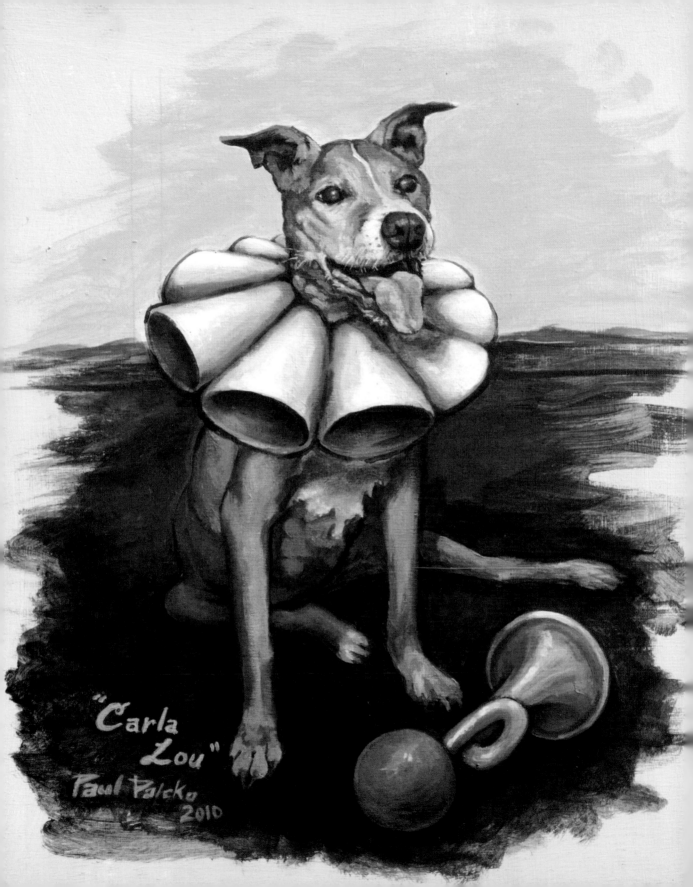

"Carla
Lou"
Paul Palcko
2010

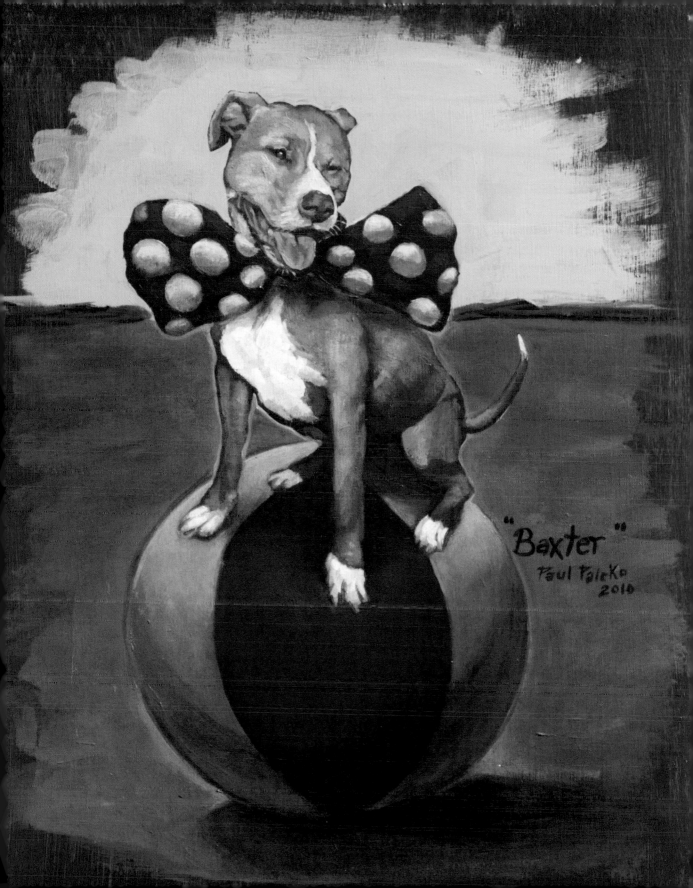

"Baxter"
Paul Palcko
2010

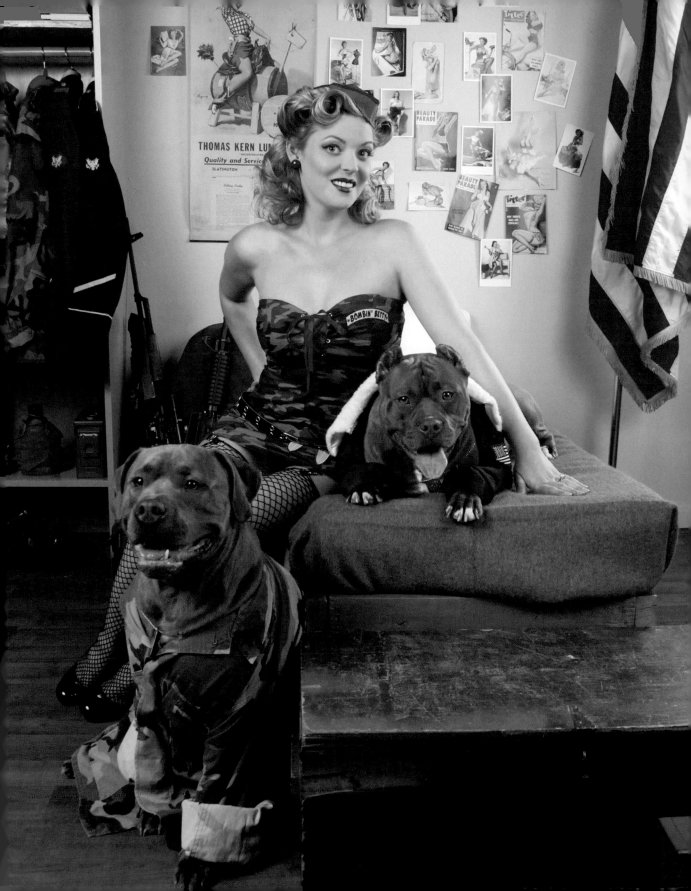

OUR "FUR"GOTTEN HEROES

★ ★ ★

n 2012, we were asked back to Animal Planet's *Pit Boss* by our friend Shorty Rossi. We chose to shoot our cover photo on their show again, but this time featuring our first male "pin-up"—Shorty himself.

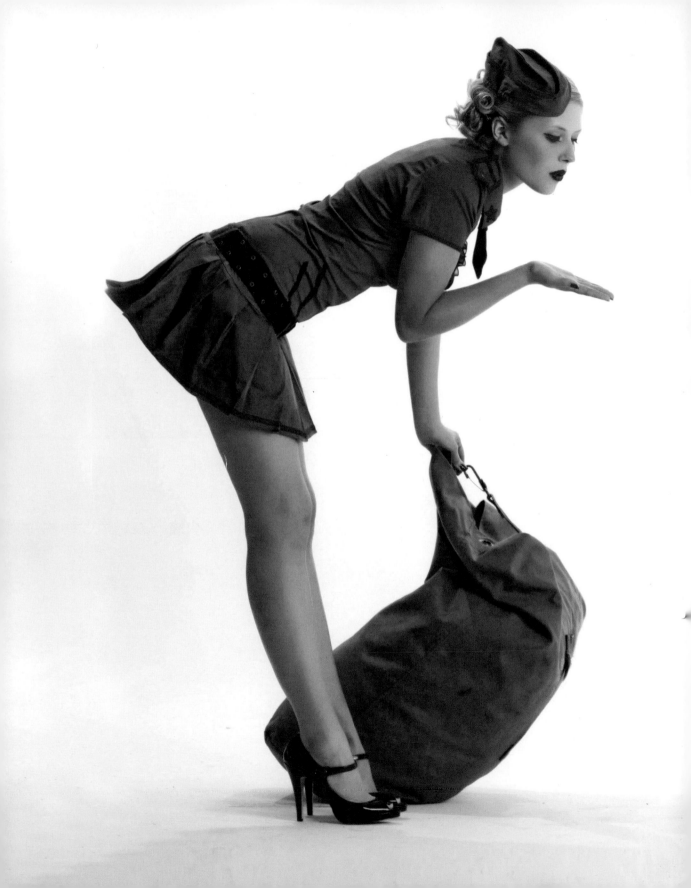

We reenacted a war time relationship to highlight Sgt. Stubby—a canine soldier—and also to shed light on breed-specific bans on military bases. We wanted this calendar year to highlight all the various heroes of our community, including police officers, nurses, military, nanny dogs, and military wives. We are very proud of how it all came together.

★ ★ ★

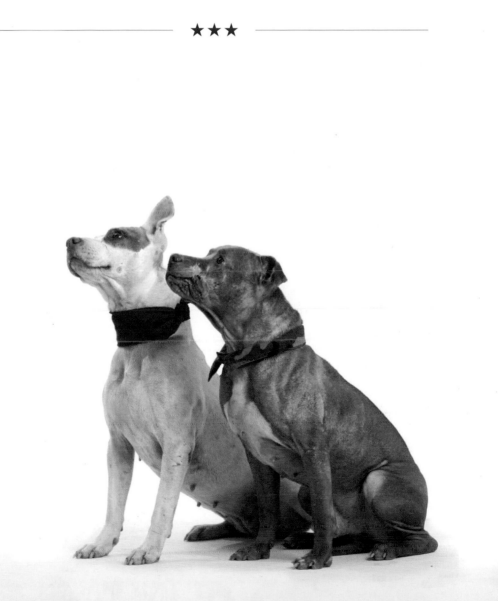

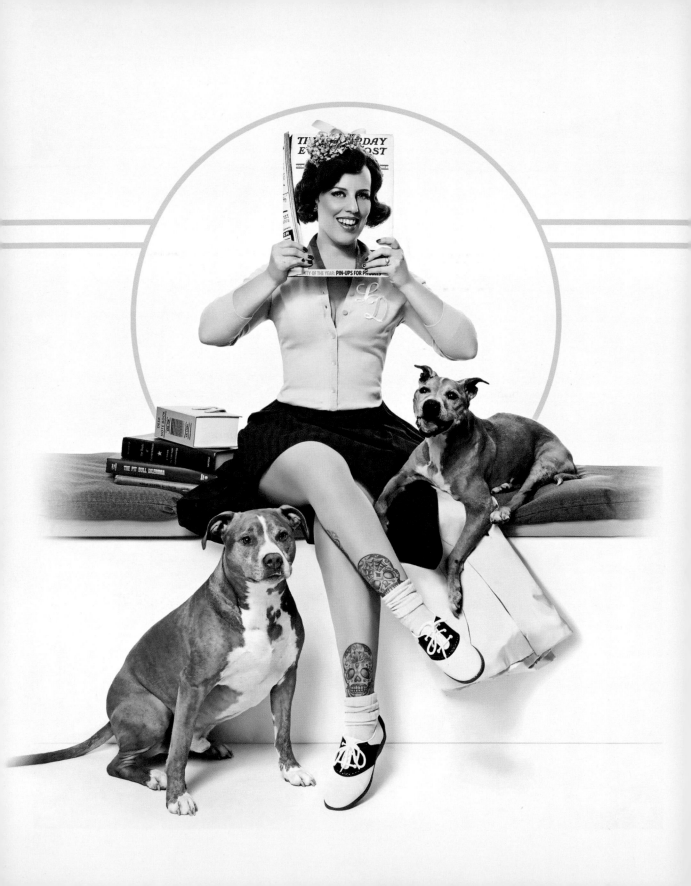

2013
HOMAGE TO NORMAN ROCKWELL

We chose a Norman Rockwell theme for 2013 to celebrate the human-canine bond. Our dogs are our family, and no one depicted family bonds better than Norman Rockwell. This calendar recreated various Rockwell images with our family dogs or adoptables. This was the first calendar that Celeste Giuliano shot in its entirety, but certainly not the last! Once again, ladies submitted to be a part of the calendar and this year, we featured many dogs from a local Philadelphia rescue and sponsored each dog for their modeling skills.

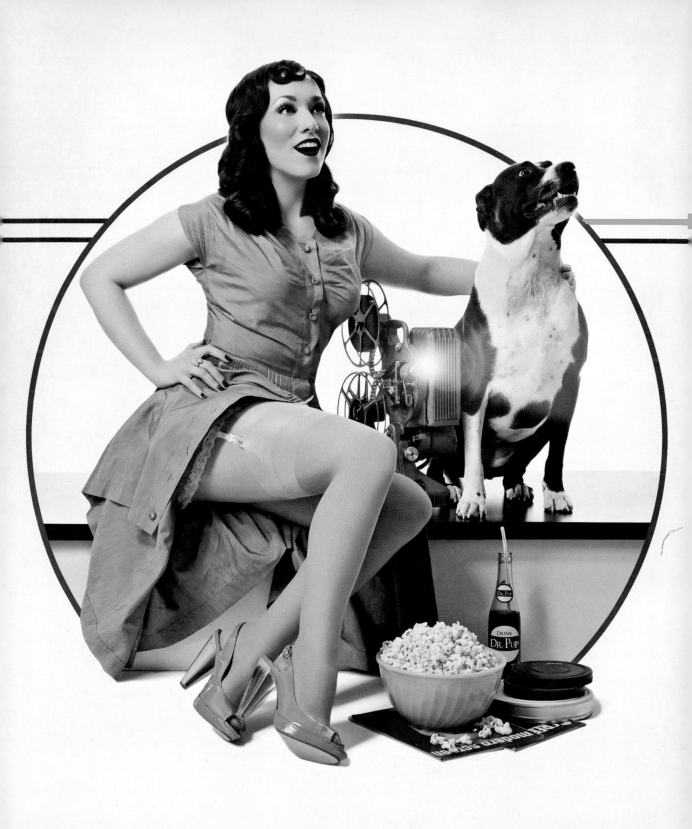

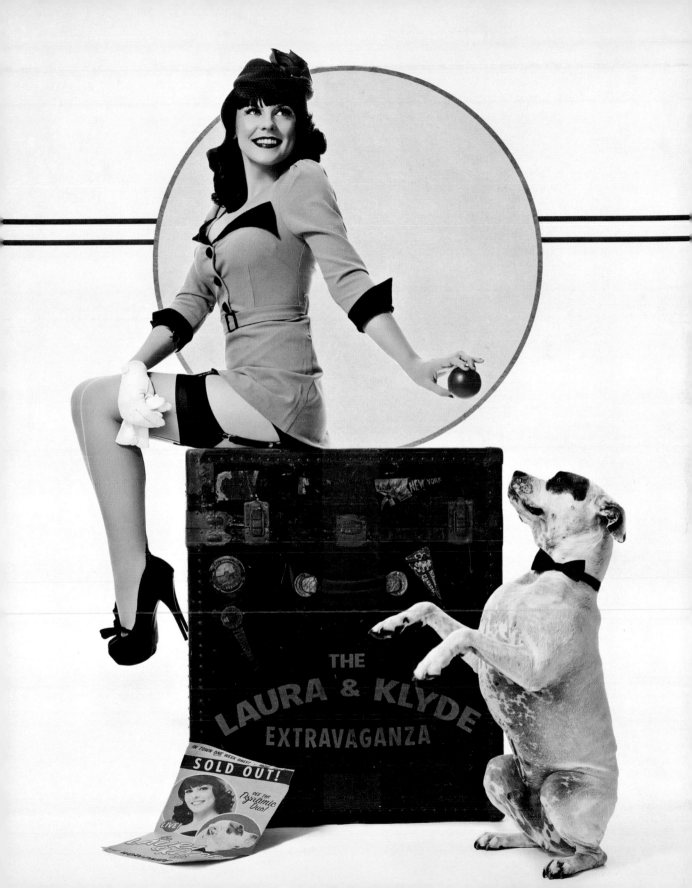

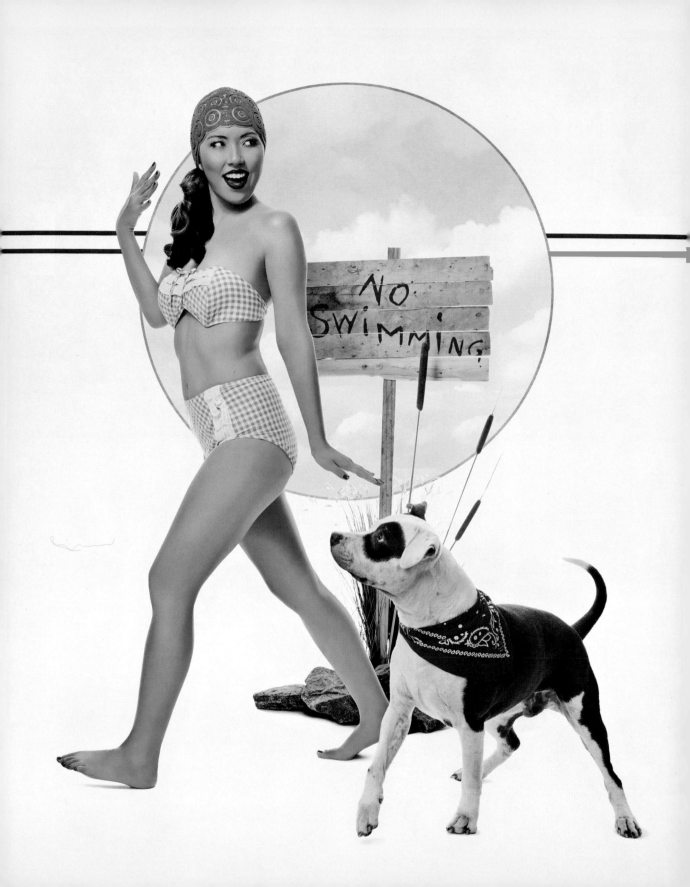

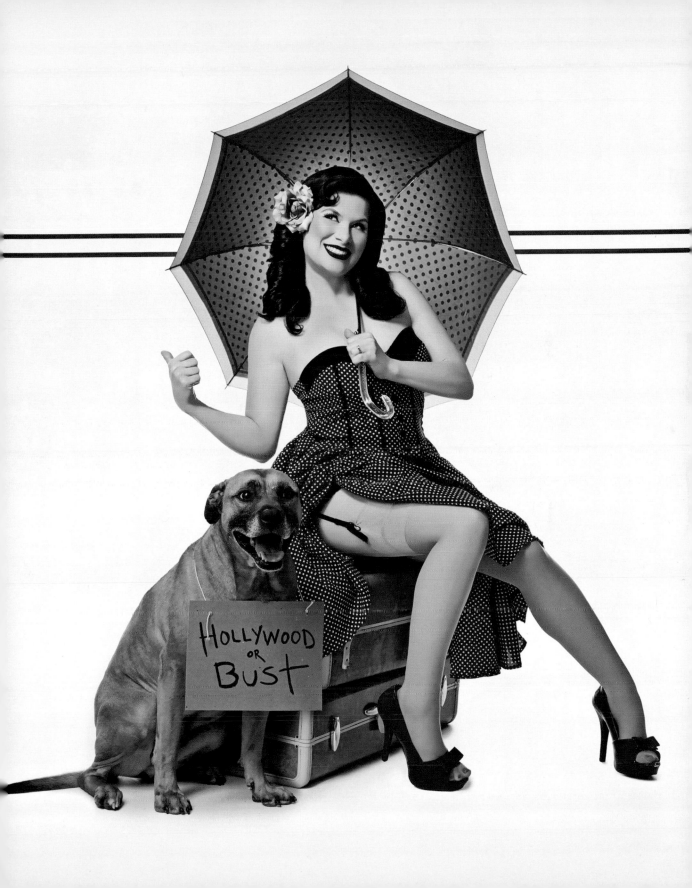

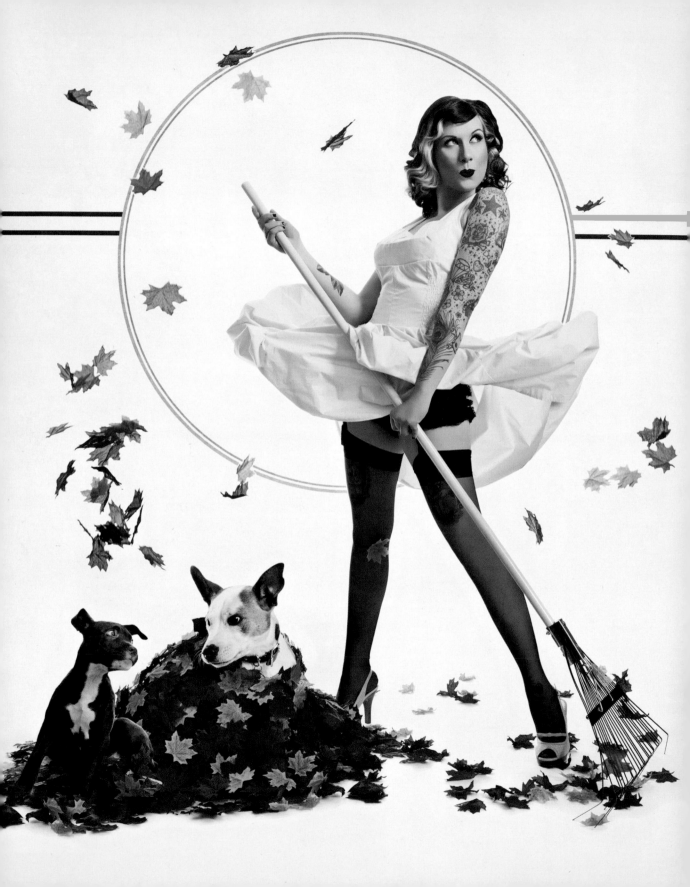

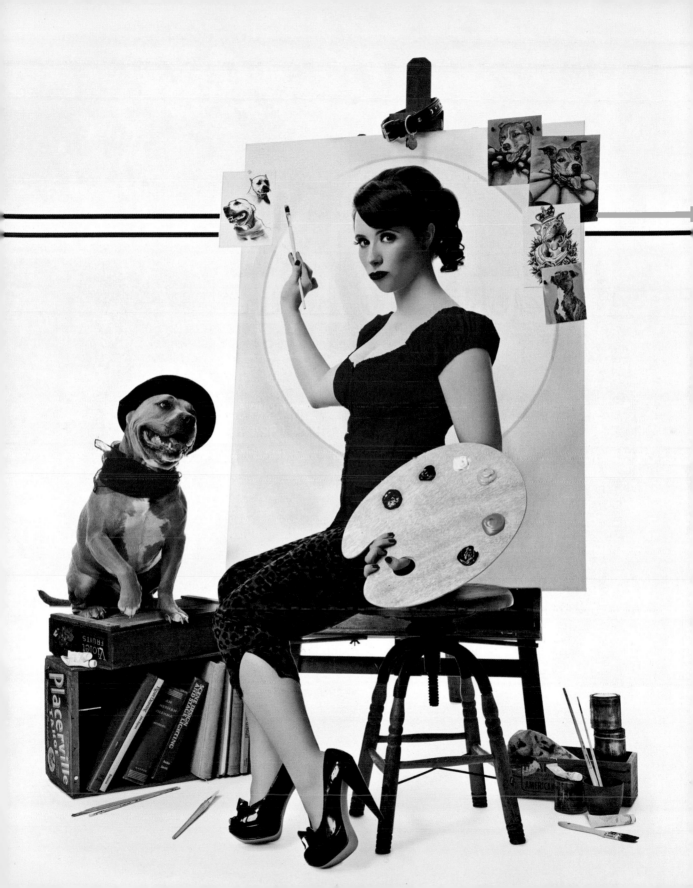

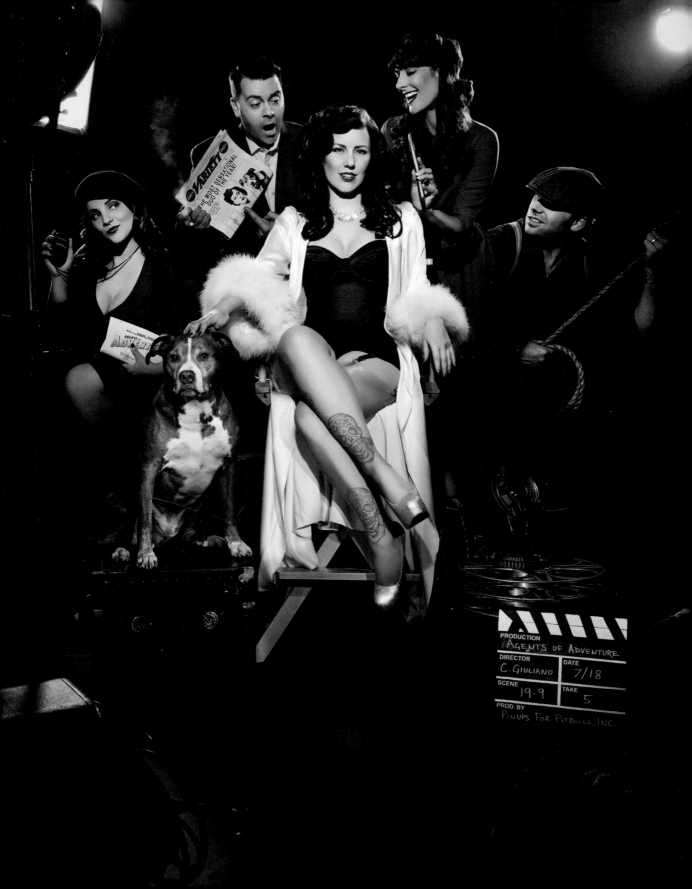

2014
AGENTS OF ADVENTURE

We decided to have some fun with the 2014 calendar and to change up the way that we shot it. We chose the Agents of Adventure theme so that we did not need to be so restrictive with the images that we printed. We had a storyline about chasing down "Mr. B.S.L." as various female agents worked with their dogs to unearth clues. We opened the model call to the public again, but this time we focused even more on people who were model citizens and advocates. These are women who are cancer survivors, surgeons, attorneys, teachers, artists, and other inspirational leaders.

73

Each year, there has been a varying degree of female advocates involved. But in the 2014 calendar, we chose from nearly 600 applications. It is a challenging selection process that takes place in hopes of finding our future volunteers and team leaders for our mission. We do not always get what we hope for, but we are often pleasantly surprised by those who do step up to the plate after their shoot.

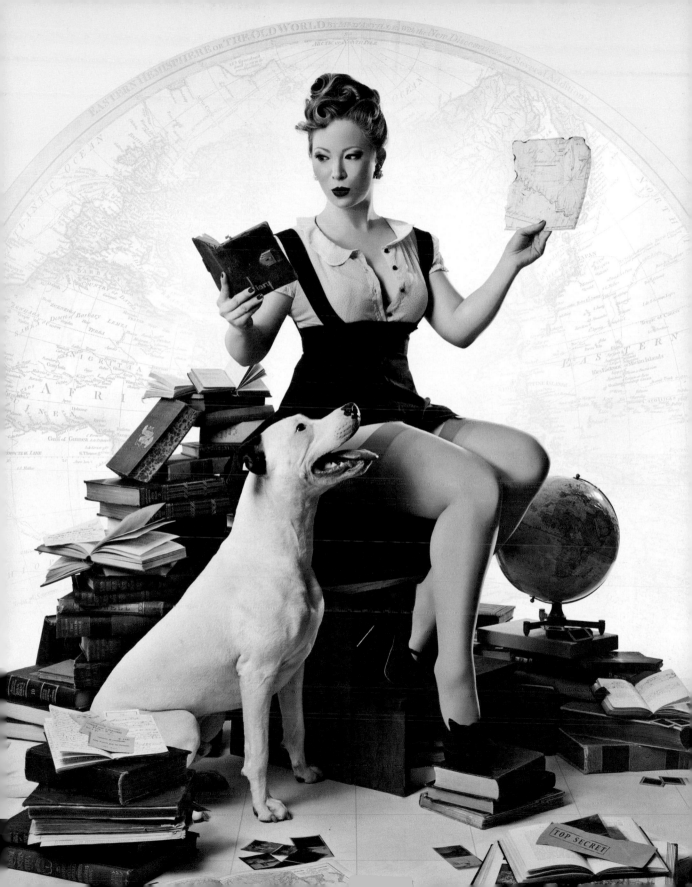

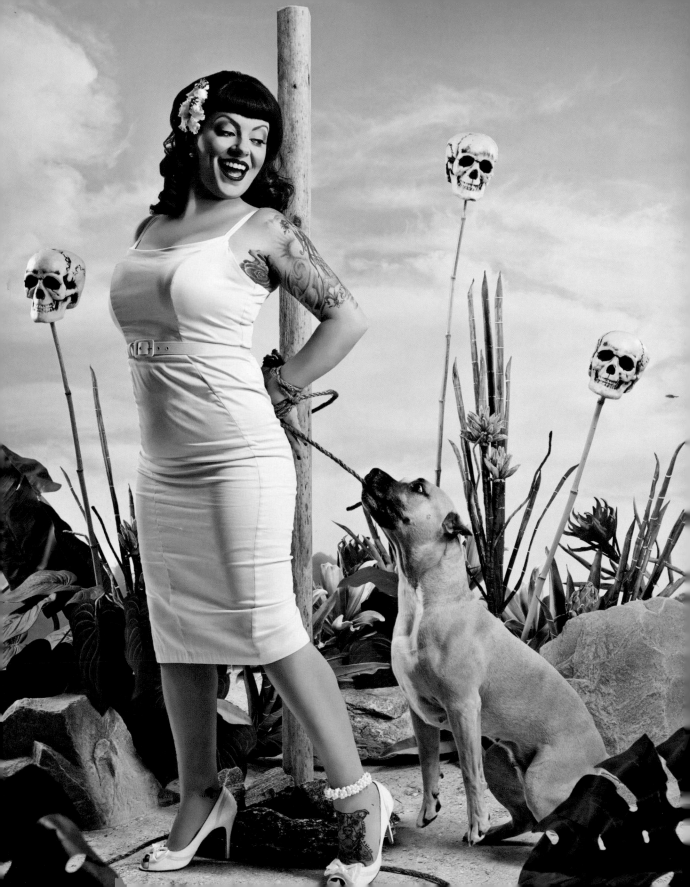

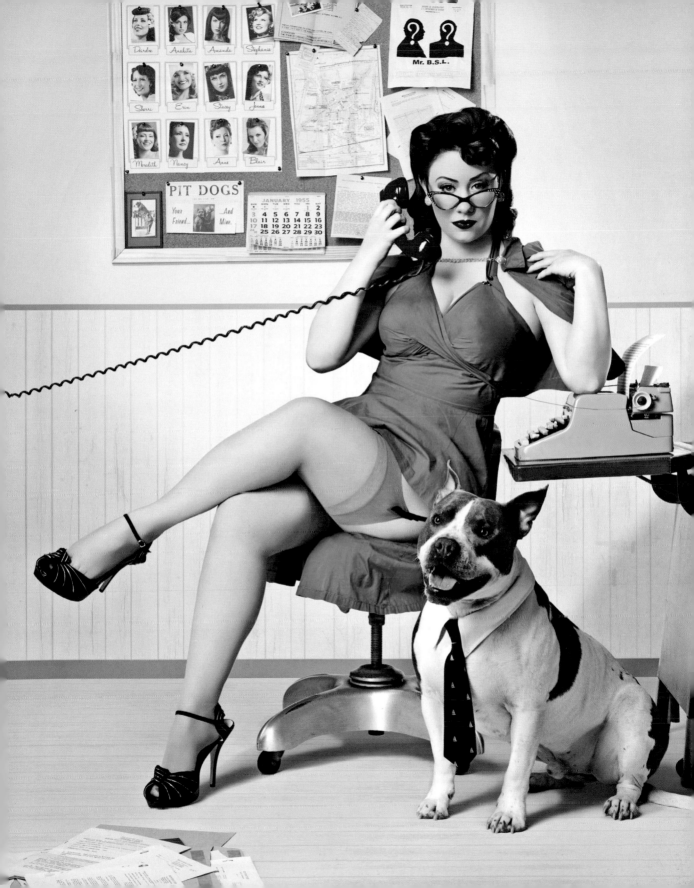

WHAT
IS A
PIT BULL?

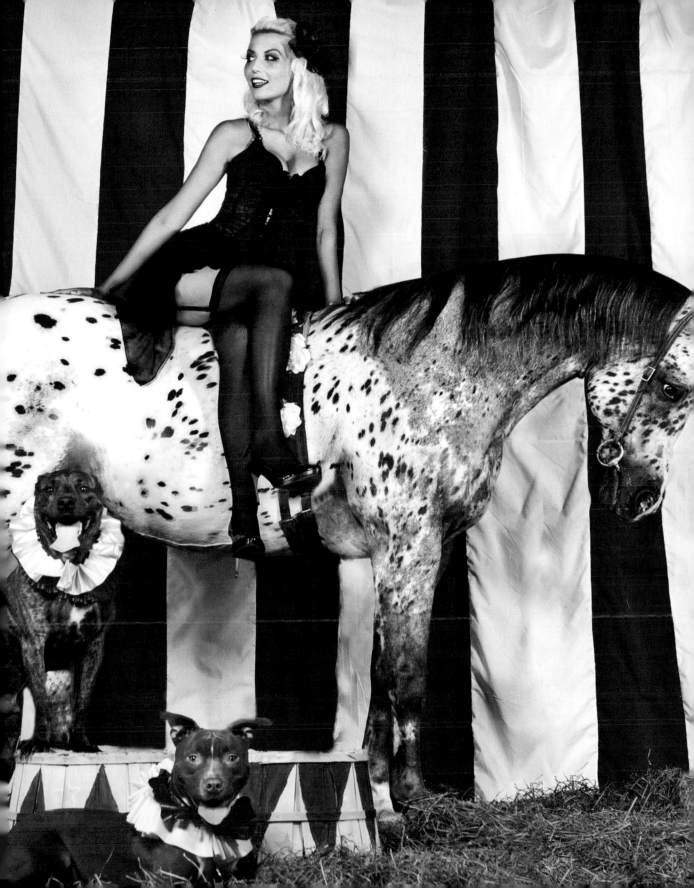

The American Pit Bull Terrier (APBT) originally hailed from England. It wasn't until the United Kennel Club (UKC) formed in 1898 that the bull and terrier dogs from America became recognized as a breed of their own.

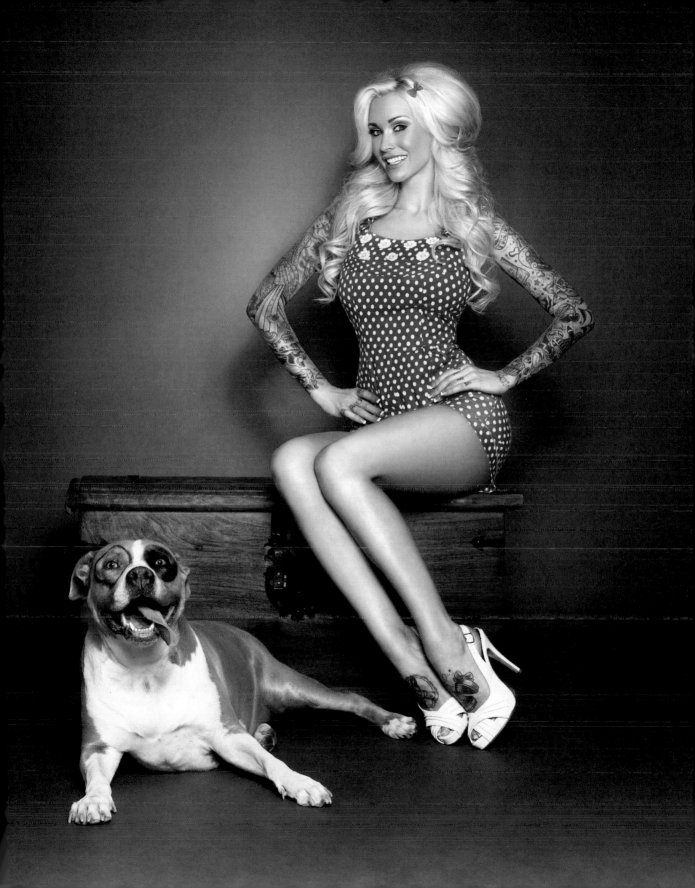

"Pit bulls have historically been bred as a people stable breed [which] has made the pit bull one of the most bite inhibited dogs in the world when it comes to people."

—DAWN CAPP,
America's Discarded Dog

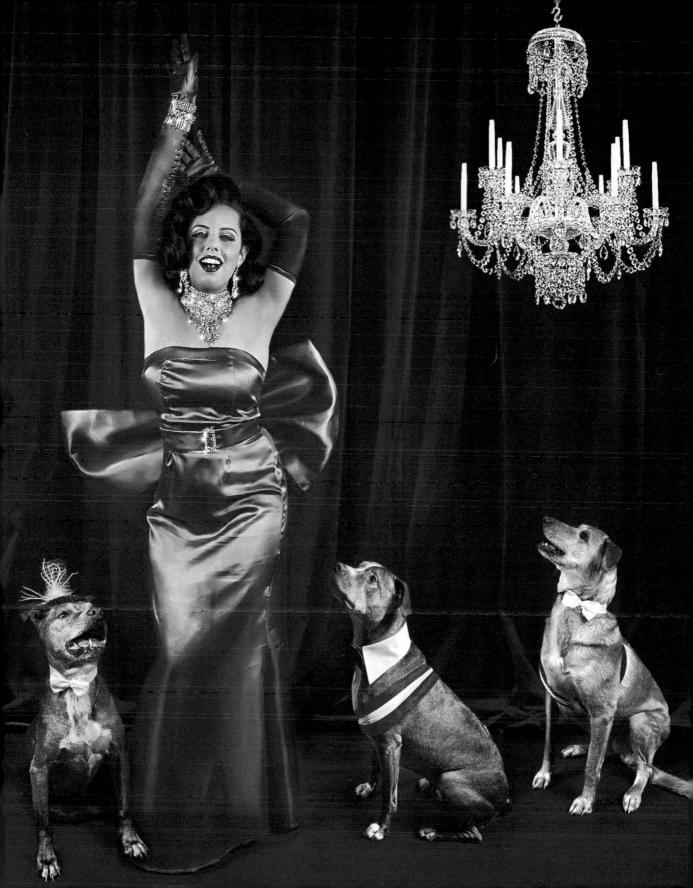

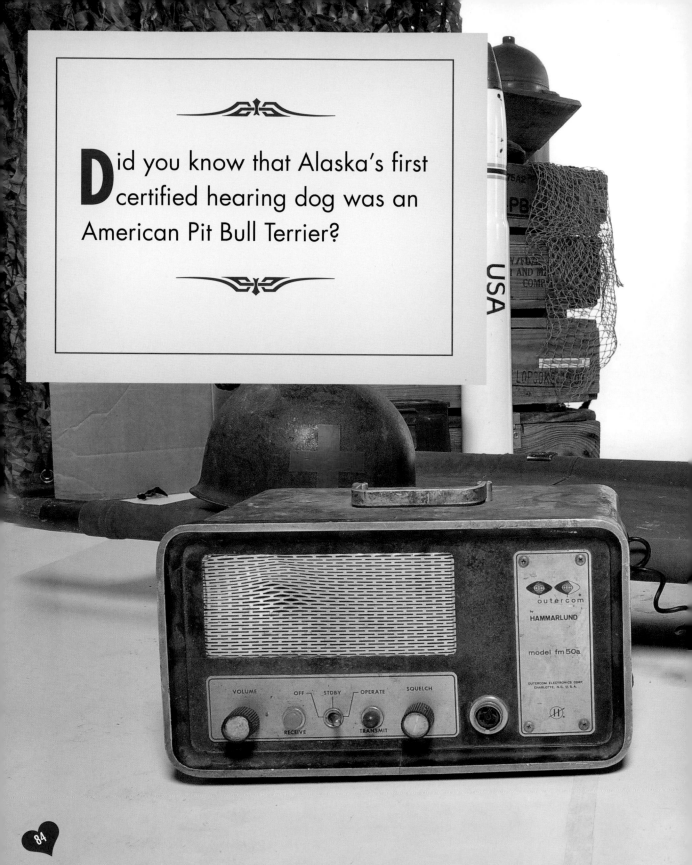

Did you know that Alaska's first certified hearing dog was an American Pit Bull Terrier?

Pit bulls have often been used as service or therapy dogs, too.

In 1903, Bud (a pit bull–type dog) accompanied Horatio Nelson Jackson on America's first transcontinental automobile trip. Bud even wore driving goggles and was praised for being the only member in the car that did not use profanity.

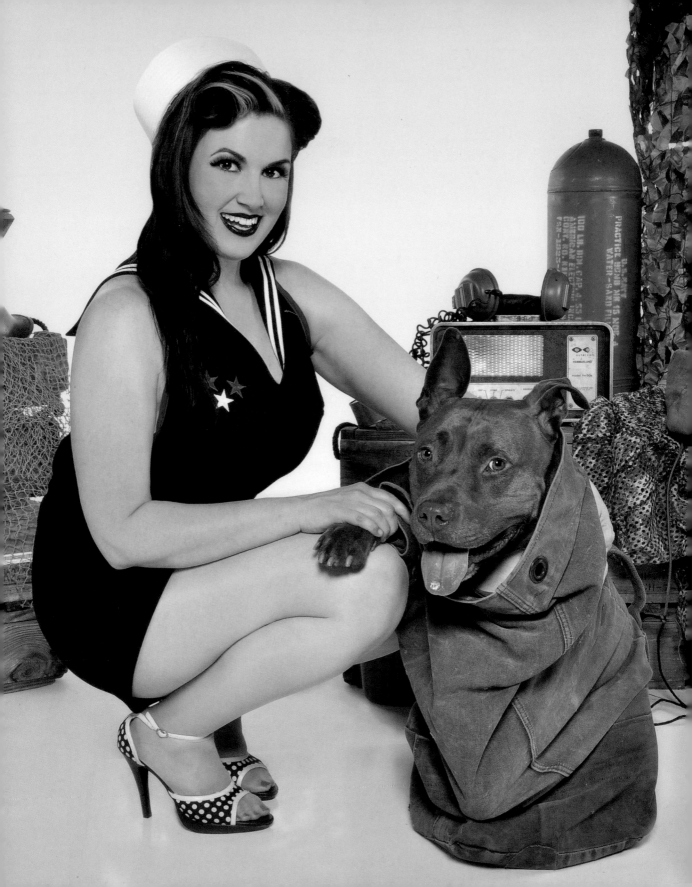

In WWI, these dogs were used in military propaganda advertisements to represent the courage and strength of our nation. A 1914 poster by Wallace Robinson featured a pit bull in the center representing America with other breeds representing the European powers. It read: "I'm Neutral, BUT Not Afraid of any of them!"

At Pinups for Pitbulls,

we know what a real "pit bull" is:

Simply put, a "pit bull" is a dog,

like any other dog, that is in need of love,

shelter, and food but might be denied

these things because of preconceptions

about their behavior.

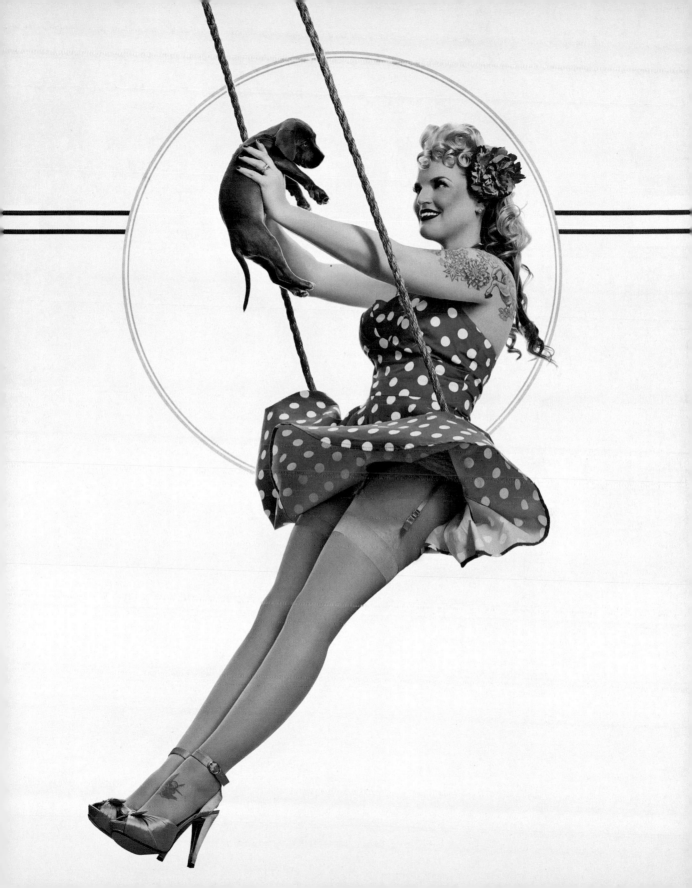

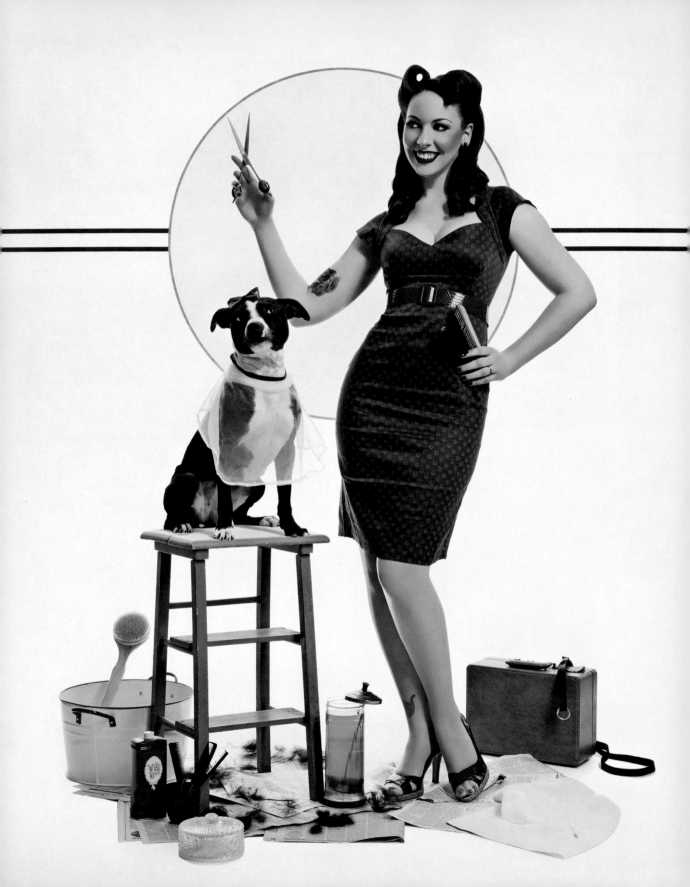

*"Since my very earliest memories,
I have always had an intense passion for all
animals, especially those in need. I feel so blessed
to be able to be a part of Pinups for Pitbulls,
where we are able to give back directly."*

–RACHEL LOVE

"*I still remember the first time I laid eyes on one of 'those dogs.' I was a junior high school student, and I'd gone to the local shelter with my parents to adopt a new cat. I remember feeling grateful that the pit bulls were behind bars and could not get close to me. I didn't think much about pit bulls after that—until Annie.*

Having attended college in West Philly, I came across a few more of 'those dogs' here and there. One day, my friend and I came across a pit bull–type dog tied to the bumper of an old, rusty car. We knew immediately that this abandoned dog—who we named orphan 'Annie'— was supposed to come with us. Taking a closer look at this poor little soul, we found that her ears had been burned by who-knows-what, her ribs were exposed, and her face was freckled with little pinhole scars. She was as sweet as anything could be, but when I brought her to my house, my roommates panicked. You can't trust 'those dogs,' they told me. Annie went to live with my friend—and with him is where she has lived to this day. She was the first one of 'those dogs' that made it into my heart, but she was certainly not the last."

—SANDY JONES

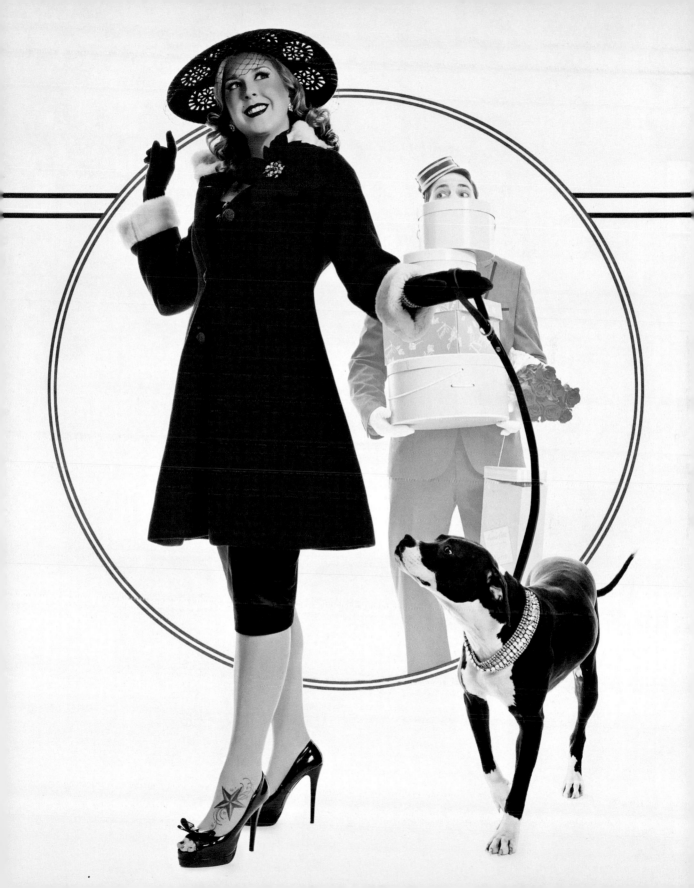

> "*After spending years working for animal shelters and animal rescue groups, I learned how amazing these mistreated and misunderstood animals are. Among the millions of animals that end up in shelters every year, pit bulls and bully breeds are by far the most abused and neglected. For being strong and devoted, they are punished and exploited. By speaking for them I can help show people how their strengths, their devotion, and their sweet demeanor should be honored and respected. Pinups for Pitbulls lets people see the kindness, sensitivity, and silliness behind their tough exterior.*"

—DORON PETERSAN,
Pinups for Pitbulls board member,
Cupcake Wars Winner/Championship Winner,
and author of *Sticky Fingers' Sweets:
100 Super-Secret Vegan Recipes*

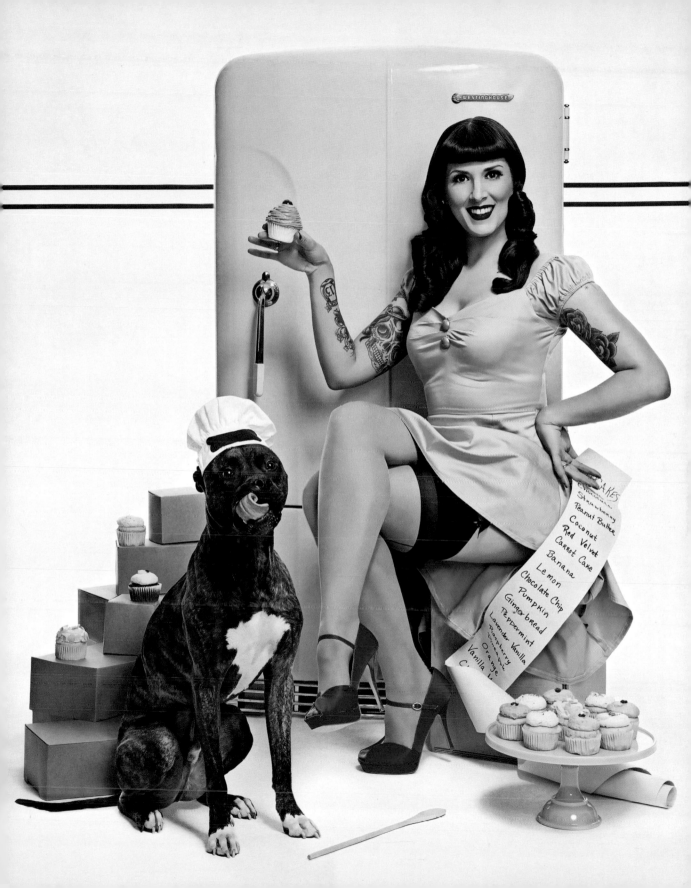

" Deirdre Franklin is the most effective pit bull advocate I've ever encountered. Because she travels to so many events that are not related to animal welfare, she is able to preach outside the choir and change minds. Add to that a beautiful person and her master's degree education, and you have a perfect combination. "

—FRED M. KRAY,
Pit Bulletin Legal News Network

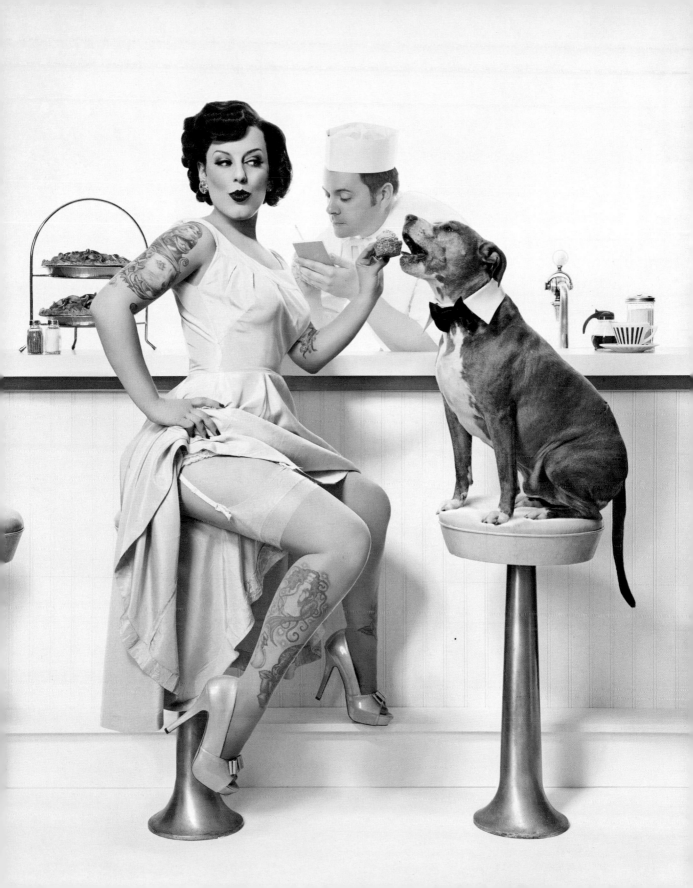

"He is your friend, your partner, your defender, your dog. You are his life, his love, his leader. He will be yours, faithful and true, to the last beat of his heart. You owe it to him to be worthy of such devotion."

—ANONYMOUS

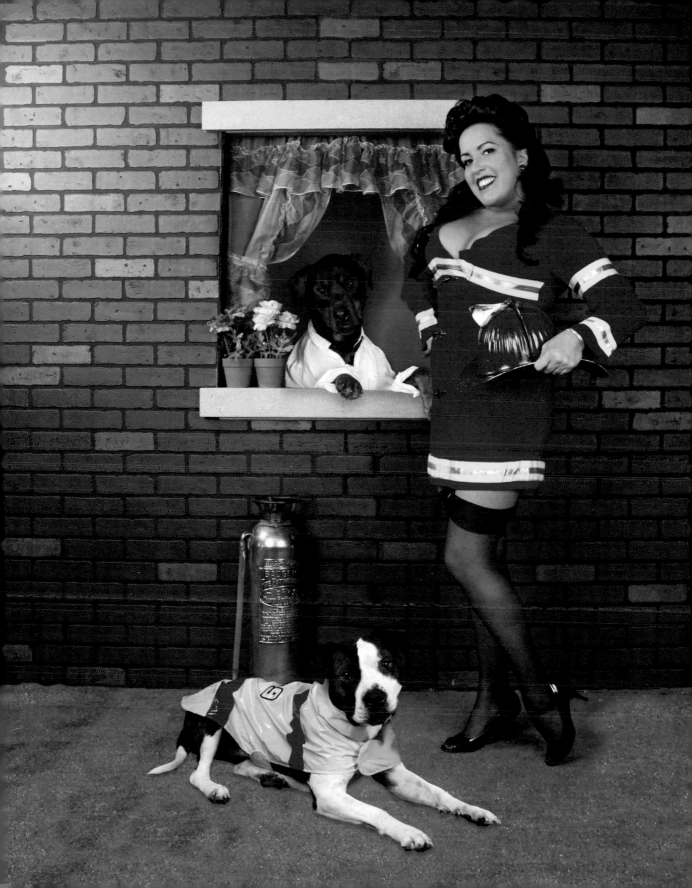

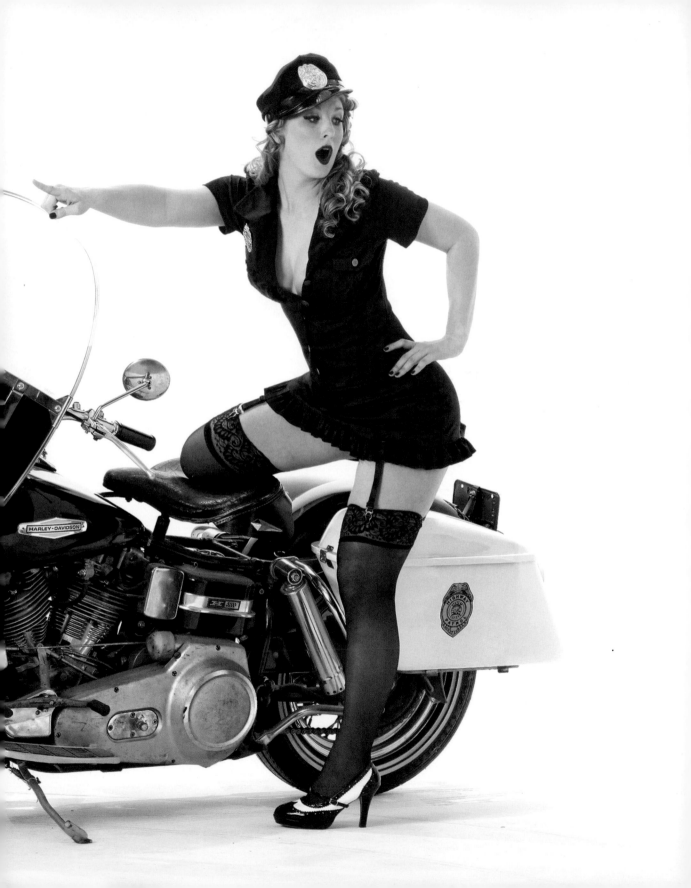

"We don't racially profile out on the roads, nor do we do that with our dogs. We don't care what type of breed the dogs are."

—STEVE GARDNER,

Washington State Trooper
(about the pit bulls that work as drug
detection dogs in their canine unit)

ARE PIT BULLS COMMON?

Having a dog as a companion animal is a privilege. Janis Bradley, author of *Dogs Bite: But Balloons and Slippers are More Dangerous* points out that the physical benefits that humans experience from their canine companions far outweigh the possible risk of a preventable dog bite. Not only can having a dog lower your stress levels, but they can also inspire social contact that otherwise might not be initiated without a dog.

Many wonderful people throughout our nation's history have kept pit bull–type dogs as companions. Theodore Roosevelt, Helen Keller, Albert Einstein, Jon Stewart, Rachael Ray and many key figures in society have kept them for pets both in the past and present.

Almost everyone involved with Pinups for Pitbulls keeps pit bull–type dogs as their companion animal of choice, many of us have additional animals in our homes like hedgehogs, cats, lizards, and so on. Additionally, many of our pin-ups are raising children with their beloved dogs. Their children will learn compassion, build immunity to allergies, and will know how to act responsibly around a dog.

ARE THERE REALLY DANGEROUS DOG BREEDS?

Michelle Welch of the Virginia Attorney General's Office reviewed dangerous dog cases and prosecuted cases found in multiple breeds such as: Dalmatians, Labradors, Golden Retrievers, Chihuahuas, and pit bulls. Despite the many kinds of dogs that she has encountered in her legal experience, she maintains that "any breed can become dangerous, because dangerous dogs become dangerous in one way: a 'bad' owner."

BUT DON'T THEIR JAWS LOCK?

Dr. I. Lehr Brisbin, a senior research scientist at the University of Georgia, published his findings that "there is absolutely no evidence for the existence of any kind of 'locking mechanism' unique to the structure of the jaw and/or teeth of the American Pit Bull Terrier." This one is just an urban legend, plain and simple.

WHAT IS THE BEST WAY TO TRAIN MY DOG?

We recommend using positive reinforcement training for your companion dog. The use of shock, prong, or choke collars can have long-lasting negative effects. By using positive training, not only can you build a bond with your dog, but you can also help them to keep a neutral, relaxed attitude so that they can enjoy the simple pleasures in life—like walks and treats. Your dog is eager to learn and to please you; this is a great way to bond and build a solid foundation based on love and trust. Training is not breed-specific. Some dog trainers believe that certain breeds of dogs require a heavy handed approach. This is simply not true. Any dog will eventually respond to positive training methods. They are reliant upon the trainer to have enough patience for positive results.

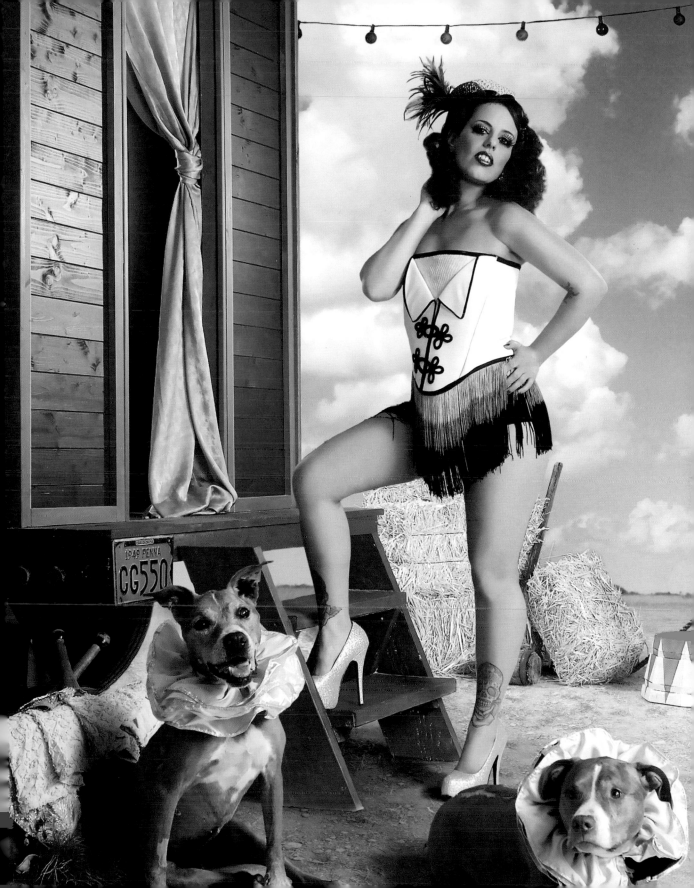

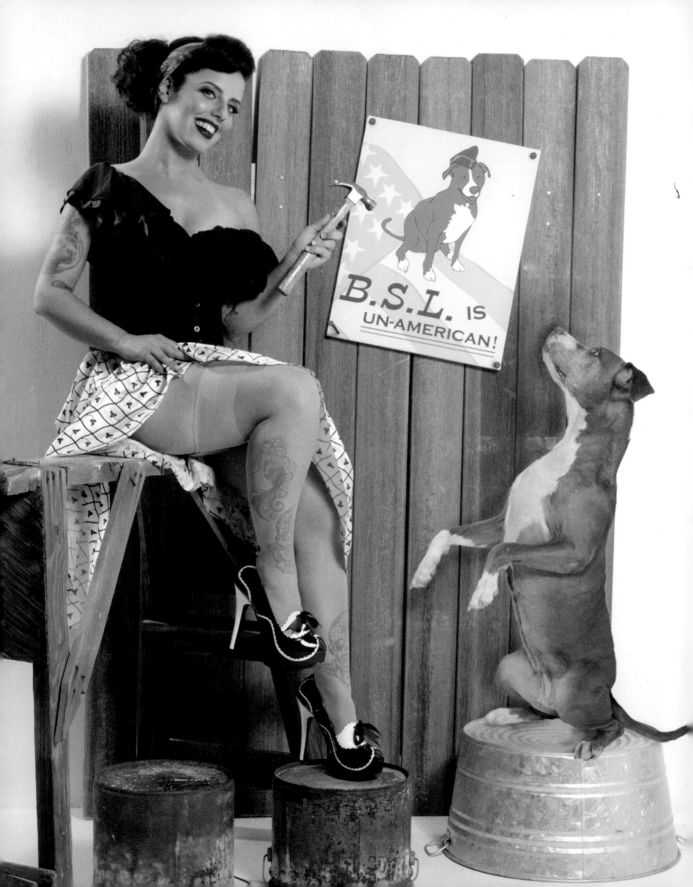

B.S.L. IS UN-AMERICAN!

WHAT IS BREED-SPECIFIC LEGISLATION (BSL)?

Breed specific legislation (BSL) has been a growing problem in the United States and much of the world. To date, there is not a single piece of peer-reviewed, scientific evidence in publication that supports the efficacy of BSL. Many cities around the world have repealed their longstanding bans on pit bull–type dogs after discovering that the removal of such dogs did not reduce the number of bites reported each year. A fifteen year ban was lifted in the Netherlands after researchers found that the number of dog bites had not decreased. The Italian government tossed out their breed-specific language and traded it in for accountability on behalf of the dog owners. Italian Health Undersecretary Francesca Martini stated on the day of the repeal "The measures adopted in the previous laws had no scientific foundation. Dangerous breeds do not exist."

Not only were dog bites not reduced in countries adopting BSL, it turned out that other dogs simply took the place as the highest amount of biters when specific breeds were removed. Breed bans are all aimed at outlaws, but by definition outlaws do not follow the law. Tax dollars would better serve communities that focused on enforcing leash laws, reducing or removing tethering, funding spay and neuter clinics, and providing community support for dealing with problem owners.

HOW DO WE FIGHT BACK?

Pinups for Pitbulls, Inc., as an organization, writes letters, makes calls to politicians and newspapers, and even visits Capitol Hill when necessary to quickly supply a potentially ignorant politician or media-representative with well-rounded, unbiased scientific data to assess. The greatest risk taken by people who own or live near dogs is the risk of not being educated about how to deal with possible problems either behaviorally, socially, or through simple preventive measures. This is the area that all organizations and communities should target according to dog advocacy groups, national humane organizations and veterinarians alike.

Many legitimate animal agencies also oppose breed specific bans. The Journal of the American Veterinary Medical Association (JAVMA) published a backgrounder in December 2013 that summed up forty years of controlled studies of dog bites and concluded that there was no reason to conclude that "pit bulls" were disproportionately dangerous. Additionally, there is a principle-confounding variable in defining whether the dog is a family dog or a resident dog (a dog that is neglected, not socialized, and is often found tethered in a yard). Human beings exert a significant influence on the dog and when we say a dog is "inherently dangerous" we are neglecting the human influence that created this behavior.

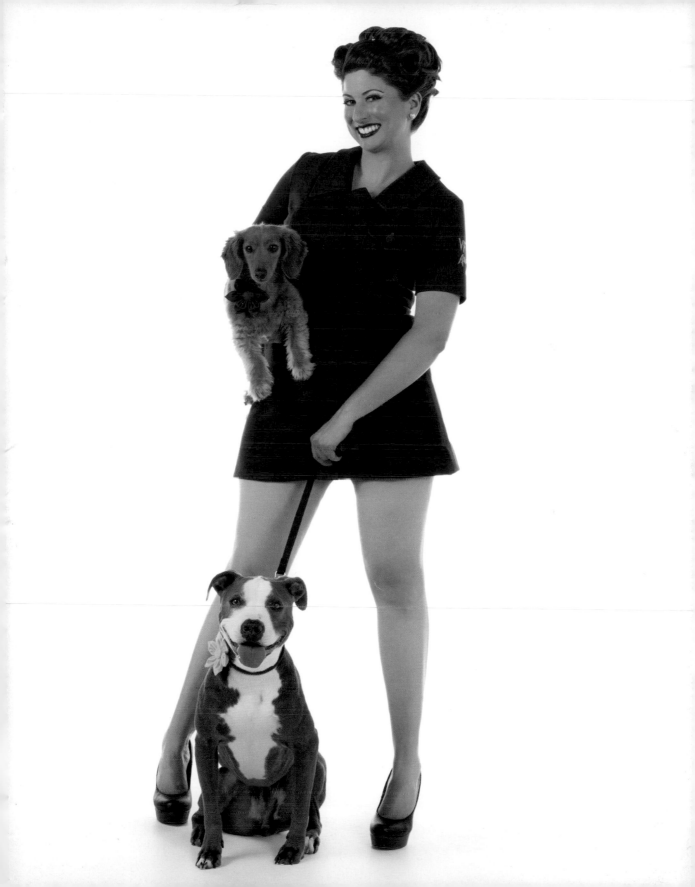

Even the American Bar Association has spoken out against BSL. In 2012, they issued a position statement regarding breed specific ordinances, which reads:

The American Bar Association urges all state, territorial, and local legislative bodies and governmental agencies to adopt comprehensive breed-neutral dangerous dog/reckless owner laws that ensure due process protections for owners, encourage responsible pet ownership and focus on the behavior of both dog owners and dogs, and to repeal any breed discriminatory or breed specific provisions.

Other organizations that oppose breed specific legislation: ASPCA, Association of Professional Dog Trainers (APDT), American Veterinary Medical Association (AVMA), American Kennel Club (AKC), Center for Disease Control & Prevention (CDC), National Animal Control Association (NACA) and The White House—just to name a few.

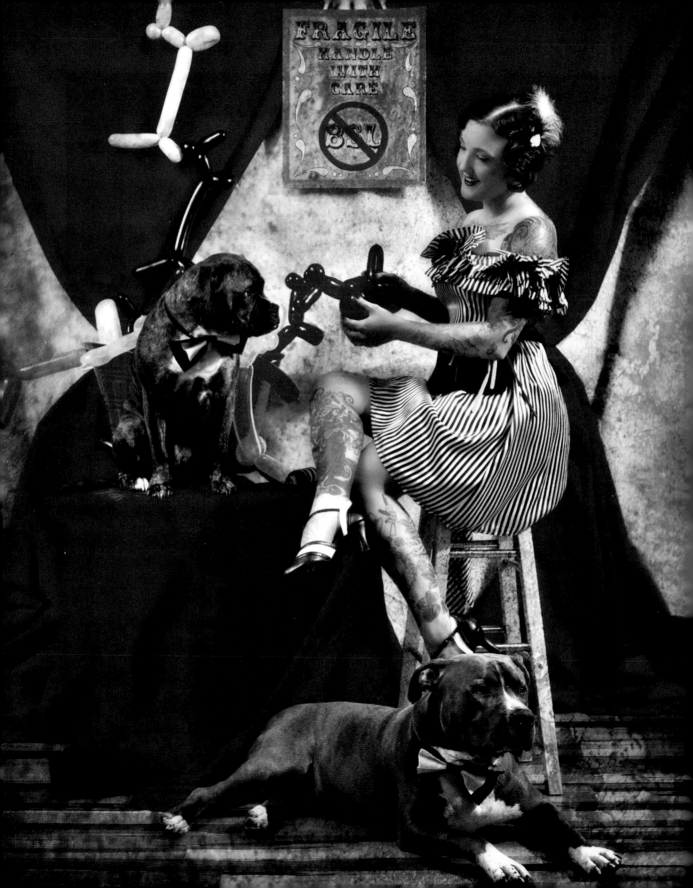

HOW DO WE STOP DOG BITES WITHOUT DISCRIMINATING?

Since pit bull-type dogs are the ones that receive the most discrimination when discussing dog bites, the best way to help them worldwide is to reduce the overall incidents of all dog bites. Here are some basic rules your local municipality can follow that experts agree will make a difference:

- Enforce existing leash laws

- Raise fines on dog-related incidents by holding reckless dog owners accountable

- Enforce tethering laws (i.e. do not allow dogs to be tethered for long periods of time or without supervision)

- Promote breed neutral spaying and neutering

- Encourage dog trainers to use pain-free/positive techniques

- Never leave a child unsupervised with a dog—ever

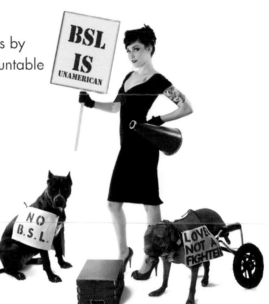

The fact remains, so long as dogs live near humans, bites are always a risk. But how much of a risk? According to Janis Bradley, an expert trainer and former instructor at the SFSPCA Academy for Dog Trainers, "Your chances of being killed by a dog are roughly 1 in 18 million. That means you are twice as likely to win a super lotto on a single ticket than to be killed by a dog."

We can keep people from being bitten almost all of the time, especially those that are most at-risk (i.e. children), through a commitment to training and common sense. Keeping children from being bitten is as easy as applying general behavior of how you would monitor a child by a pool. In *Dogs Bite*, Janis Bradley cautions, "If you wouldn't let them do it around a pool, don't let them do it around a dog."

You hear so much about bites in the news, especially naming specific types of dogs like "pit bulls." Newspapers are nine times more likely to include the breed of dog in their headlines when the story allegedly involves a pit bull. An example used in an educational film that we sponsored called *Beyond the Myth* mentioned a child who was killed by her family's Malamutes. This story was circulated in only eighteen news outlets, but a similar story involving a pit bull mix was reported in nearly three hundred articles including international coverage. The bias is clear.

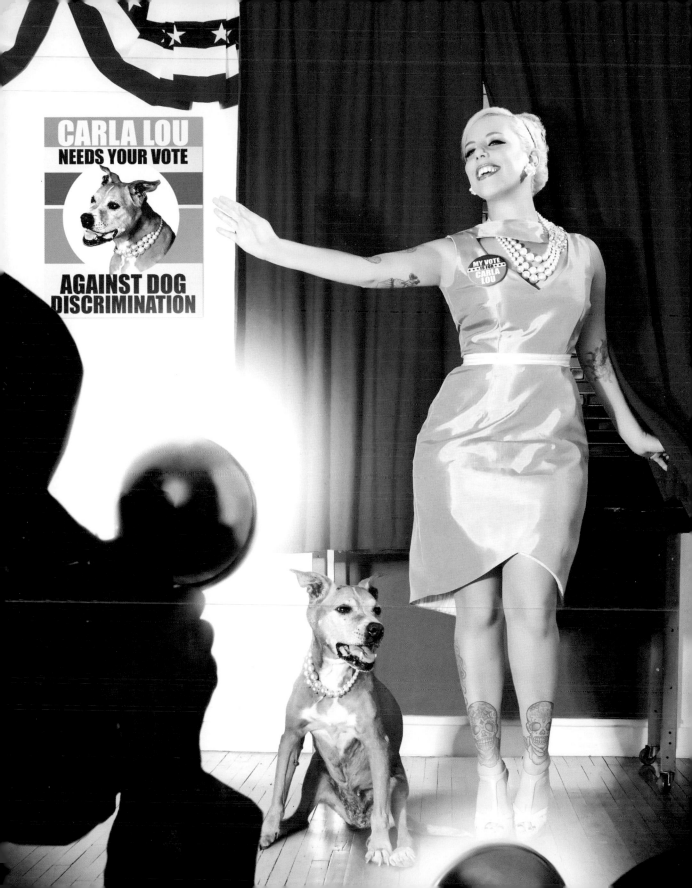

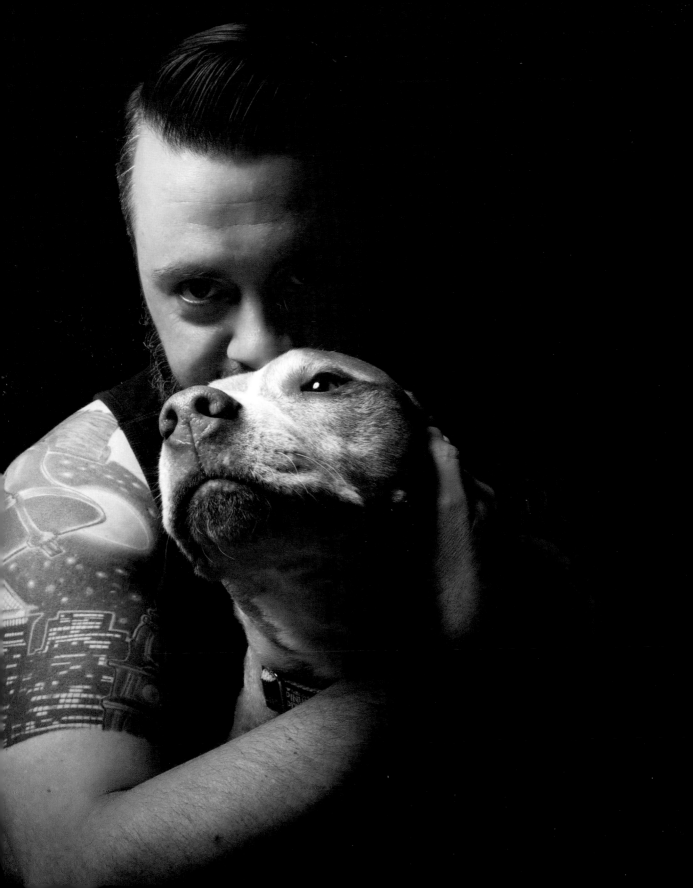

I have spent my entire life living with dogs of all breeds. Whether these dogs were in my home or the homes of my relatives, I had learned to love them for what they each represented as individual beings. I grew up with German Shepherds, Chow-chows, Rottweilers, pit bull mixes, Lab mixes, Chihuahuas and more. I never knew any breed or breed mix to be more inherently aggressive than any other. They each had a personality and each dog was very different based on its surrounding, upbringing or task for which it was raised.

When I first learned about Pinups for Pitbulls, I was appalled that an organization was even necessary to bring awareness about breed discrimination and the myths often portrayed in the media about one 'breed' being more aggressive than another. At the time, I did not follow media stories, let alone myths, which would sway my beliefs to benefit any type of hysteria. When I first met Baxter Bean, he lovingly jumped up to greet me. My first response was to get down on the ground and praise him for showing me his utmost attention. Deirdre asked me if I was 'okay' with him being a 'pit bull' and I responded, 'Sure! He's just a dog!'

After learning about the politics surrounding these dogs, I immediately became involved as a volunteer and learned as much as I could about the issues and media connections. It reminded me of any other hype which strove to drive people into uneducated, misguided thought processes about any other issue. I started attending seminars and advocacy events to learn more about other people's line of thought and how they reacted to messages which were not only fear-based but scientifically unproven and very biased toward certain agendas.

At this point, I have been involved with Pinups for Pitbulls for over six years and have brought my love of dogs and twenty years of financial experience to help propel us to the next level. The message of unbiased love and positivity that we spread has helped the organization grow to unprecedented levels from a grass roots effort. Everything that Pinups for Pitbulls has become is based on hard work, determination and acceptance of all people, all breeds and all walks of life. This is a group that thrives on mutual sharing of a positive message—and looks great doing it! We hope to inspire others to learn factually based information and to spread the positive message that all dogs are individuals and they thrive when they are treated with love, respect and have the opportunity to live in a family based environment.

—JEFFREY LONCOSKY

123

BAXTER BEAN

Baxter Bean and his littermates were dumped at the rescue where I volunteered at a PetSmart in New Jersey. He was only four months old and had already been subjected to horrible cruelty. His back was severely burned by either a caustic chemical or fire, and he lost some of his fur and much of his spirit.

I had two dogs at the time I decided to foster him—Carla Lou & Howie. Both of them were excellent teachers and would make great friends for Baxter to learn from. I took him home and worked on getting him out of his shell while the dogs taught him manners and the basic ways of being a dog. Baxter wouldn't catch a ball; he would just look at you with sad eyes asking why you tossed something at him. The rescue would borrow Baxter to take to schools to educate children about the horrors of animal cruelty.

After a few months went by, the rescue asked me to find him a new foster. It was then that I knew that I could not let him go. In the rescue community, we call this "foster failing." He took a lot of work to get out of his shell, but now, at the age of 9, he is a handsome elderbull with a keen sense of who in the room needs a hug. He will sit his 70 plus pounds of pure love right on your lap. You couldn't turn him down—even if you wanted to! He also now loves to catch toys and has learned to balance them on his head until told to "get it!" Rest in peace sweet Howie & Carla Lou. Thank you for teaching Baxter how to be a dog and a gentleman.

Baxter became an inspiration to me and to the rest of the Pinups crew. Now let's meet some other pit bull pups who have touched our hearts in the last ten years.

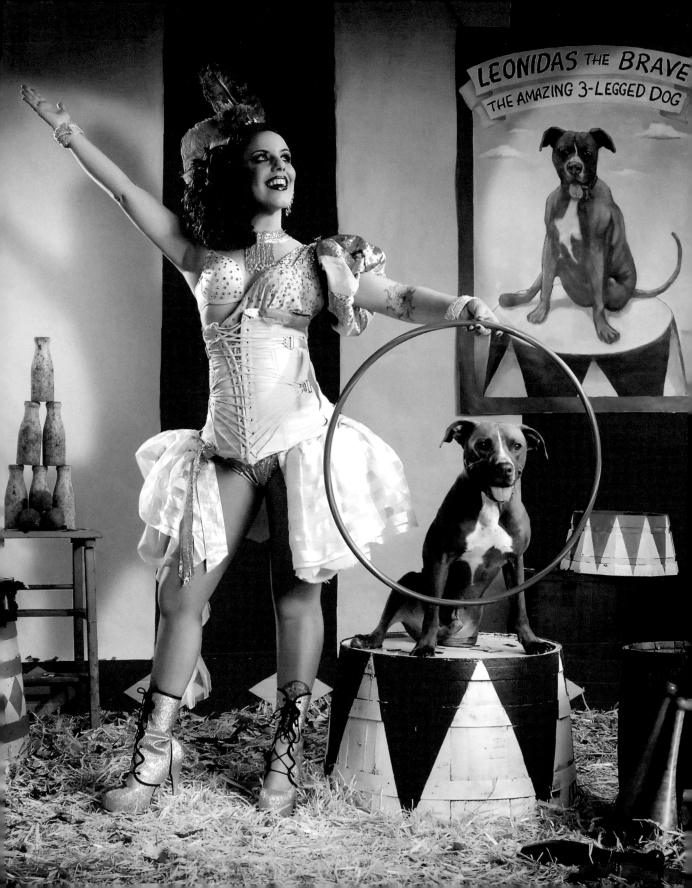

LEONIDAS THE BRAVE
THE AMAZING 3-LEGGED DOG

What has three legs, only two paws, and the fastest wagging tail west of the Mississippi?

LEONIDAS
THE AMAZING THREE-LEGGED DOG!

"*Leonidas is a registered therapy dog who loves visiting kids and veterans. Every week he visits the VA hospital's post-traumatic stress and traumatic brain injury wing. He slips and slides around the tile floors in schools and hospitals, but he brings the biggest smiles to everyone he meets.*

When Leonidas was only a few weeks old, he was held as bait over a chained and abused dog that ripped both of his back feet off and part of his rear left leg up to the knee. He was anonymously dropped off at a shelter and found his way into our hearts and home. Thanks to the generosity of Pinups for Pitbulls and the donated time of our veterinarian, Leonidas had his left rear leg amputated. Today, Leonidas is the happiest dog you have ever seen and will touch your heart with his big pit bull smile."

—KATIE & ANTHONY BARNETT, *Game Dog Guardian*

JOEY

"*Joey was rescued from a felony animal cruelty case in Kansas in the fall of 2010. Game Dog Guardian (GDG), a Kansas-based dog rescue and advocacy group evaluated the dogs for the sheriff and made recommendations for placement. On the scene, Joey was a toy-driven dog who needed further evaluation. Within just a few days, GDG found Joey to be an awesome family dog who just really loved tennis balls! After a short time with GDG, Joey was adopted by his new mom after she saw him on a walk around town one day and immediately fell in love.*"

—KATIE & ANTHONY BARNETT, *Game Dog Guardian*

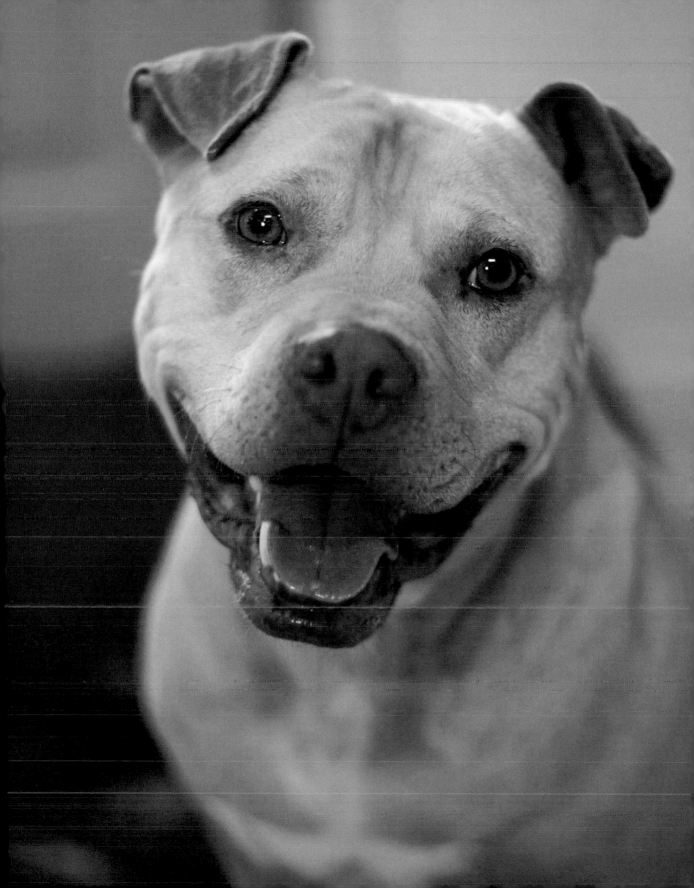

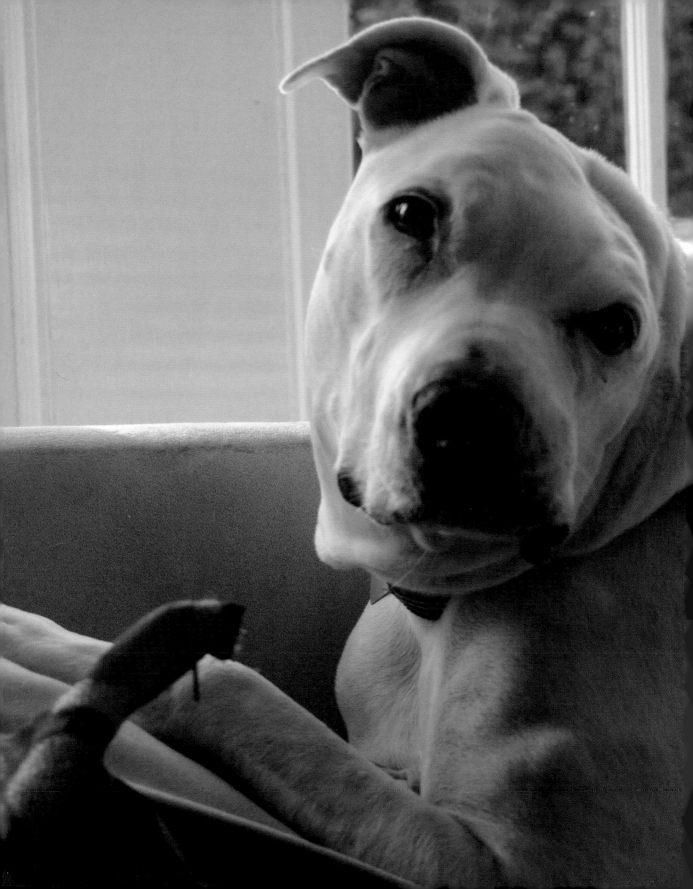

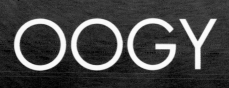
OOGY

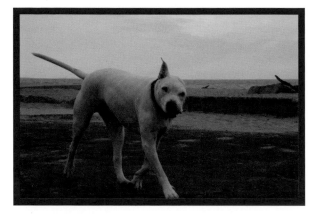

"Any time I'm asked if I'm Oogy's owner I say, 'No, I'm his father.'

When the police found him in a drug raid, what was left of him was refuse. Not quite four months old, he had been used as bait for a fighting dog. There was a hole the size of a softball where the left side of his face had been; his ear had been torn out, the cheekbone had been pulverized and part of the lower mandible broken off. After being ripped apart, he'd been discarded; thrown into a cage, he lay unattended for almost a week without food, water or medicine, suffering in unimaginable agony. The police took him to a local animal hospital where, simply because it was the right thing to do, the staff worked for hours to save him. They had no idea what waited on the other side: after such horrific treatment would the dog be fearful of humans, aggressive towards animals—or both?

He was neither. Ever after, he took complete joy in everyone and everything. My sons and I met him shortly after the surgery. The left side of his face was all scar tissue. I was told he was a pit bull. Before that moment I wouldn't have voluntarily put myself in the same room with a pit bull. I had never met one; my fears were wholly irrational, based only on the negative press about them. But within those few short minutes we had already fallen madly in love, and his breed was of no consequence.

That was in 2002. We later learned that the dog we named Oogy—because he was so ugly—is a Dogo Argentino, another of the so-called bully breeds. Oprah Winfrey discovered his story and, after he appeared on her show in 2008, I was contacted by a literary agent who asked if I'd ever considered writing a book about my experience. The book, Oogy: The Dog Only a Family Could Love, was published in 2010. The story resounded; publication coincided with the growing awareness and appreciation of canine sensibilities and the evolving rescue movement; as a result, the book spent some thirty weeks on the New York Times extended bestseller list. It has been published in seven other countries. On Christmas Day 2013 it was downloaded almost 10,000 times. Oogy is known around the globe.

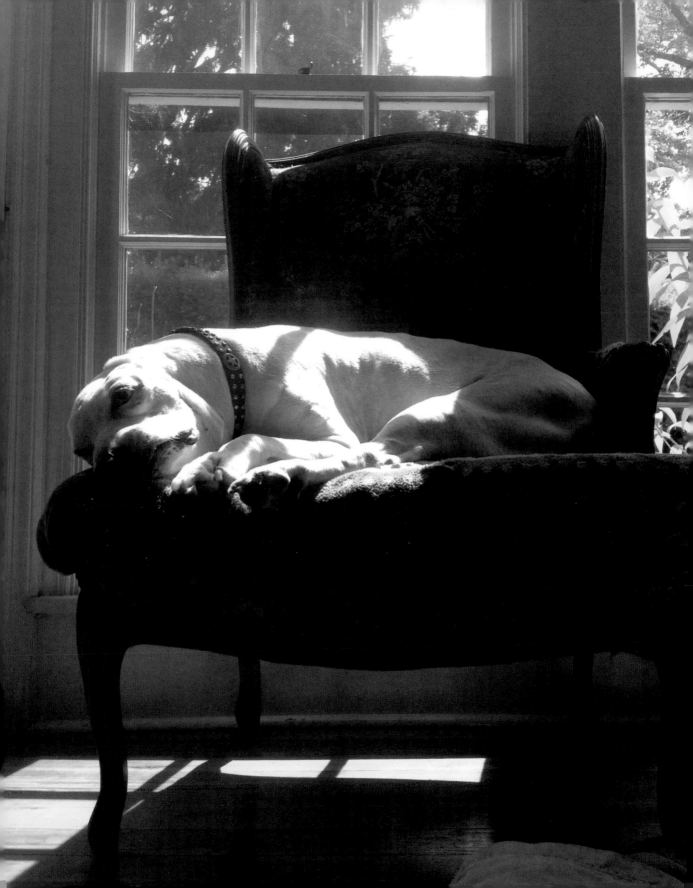

In a sense, Oogy was never only ours. His has been a life held in trust, a tribute to the collective efforts of the police who found him and a hospital staff who, against all odds, saved him; the embodiment of all the good things that result from people who care about animals and rescue them and fight for them in all the many ways that this struggle is carried forward. I think often of the example they set. It is not only my family who are the better for it.

People tell me that I did a good thing in rescuing Oogy. I don't think I did anything that countless other people wouldn't have done. I was just in the right place in the right time. What he survived is unspeakable. Though people think I saved him, I know he also saved me. We have a very special relationship, Oogy and me. We are the missing pieces of each other."

—LARRY LEVIN

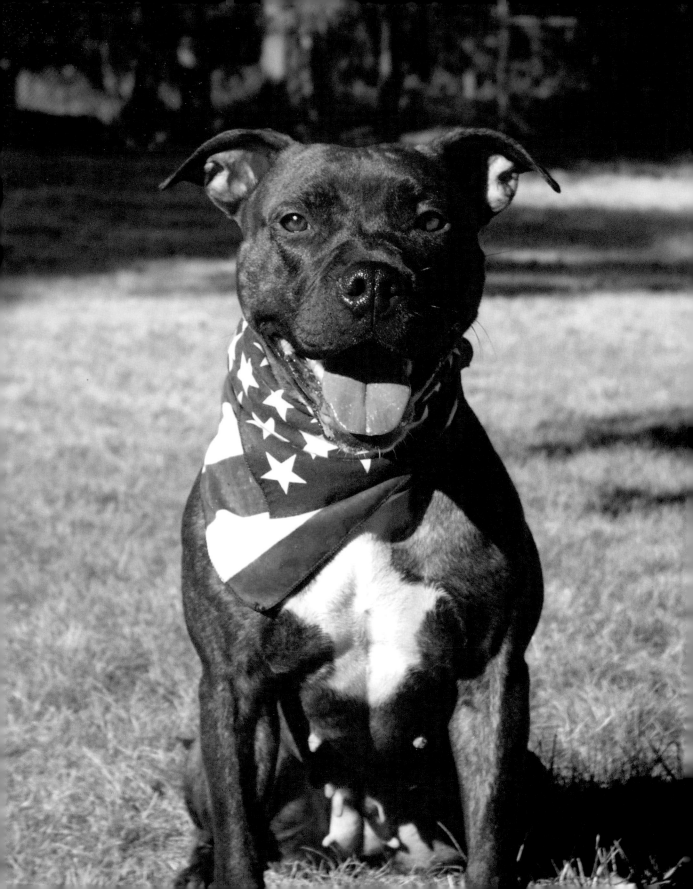

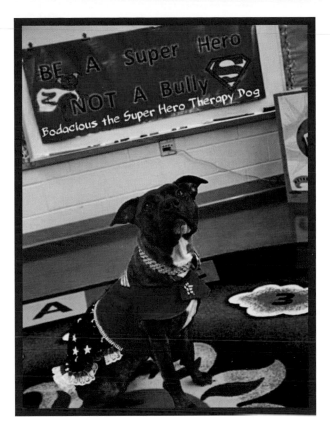

BODACIOUS

"From educating about her breed type, raising money for fighting cancer, autism awareness and to restore the Jersey Shore, to assisting some get over PTSD, Bodacious is a true canine super hero with compassion that you simply cannot match. Bodacious was the proud recipient of New Jersey VMA Animal Hall of Fame Award of Merit. She has been honored by the Positive Pit Bull organization with The PPB Best Breed Ambassador Award. Bodacious has also been an American Humane Association Hero Dog nominee. Featured in news articles, calendars, and magazines portraying a positive image for dogs, she further helps to show the world all that is good in bully breed dogs."
—THERESE WEINER

HECTOR

"*Hector came from the dogfighting ring on the property of NFL quarterback Michael Vick. He was evaluated and rescued by the organization Bad Rap and later we adopted him. Contrary to popular belief, Hector needed no rehabilitation to learn how to be a proper member of society. He simply needed a chance to survive and be himself. Because of his happy personality, he was quick to pass his canine good citizen test, his temperament test, and his therapy dog certification. He has spent his years as a therapy dog doing a variety of things including visiting nursing homes and hospitals, visiting schools and shelters to teach kids about compassion and how to safely approach dogs, and showing everyone that all dogs are individuals and shouldn't be judged by their past.*"

—CLARA & ROO YORI

WALLACE

"*Wallace had a few homes in his life and he almost went without a forever home when he was deemed a liability in the shelter. A young and wild dog with bad manners, we knew that he needed a way to channel his energy and enthusiasm. We first tried weight pulling and, while he was a natural at it, his true passion turned out to be flying disc. Along the way, Wallace went from foster dog to best friend. He made a name for himself in the disc dog world, winning the 2006 Cynosport World Games and the 2007 Purina Pro Plan Incredible Dog Challenge. People who watched him play in person or in his popular YouTube videos couldn't be afraid of Wallace while they were being entertained by him. Wallace's electric personality and disc skills opened minds and warmed hearts. Wallace eventually retired from dog sports and spent his retirement rolling in the grass, playing fetch, and hanging out with his one dog pal, Angus. His story was so fascinating that author Jim Gorant penned a book titled* Wallace: The Underdog who Conquered a Sport, Saved a Marriage, and Championed Pit Bulls—One Flying Disc at a Time. *Shortly after the book release, Wallace collapsed from a burst spleen and needed emergency surgery. The diagnosis was grim: hemangiosarcoma, a cancer with a prognosis of just a few months. Wallace, true to form, exceeded expectations. He spent his last year of life living well and completing his bucket list. He swam in the ocean, met Betty White, went canoeing, rode in a motorcycle sidecar, passed his canine good citizen test, and rode in a convertible.*"

—CLARA & ROO YORI

TATORTOT

I have been an approved foster for Ruff Start Rescue in Minnesota for a little over three years. I have seen some of the worst things and some of the greatest things through this rescue, but I never would have guessed that a pit bull foster would save my son!

TatorTot was originally supposed to be a foster-to-adopt situation, then after months of trying to make him fit to the family, they asked for a different arrangement. I decided to take him in, but I thought that he was going to be too much energy for my family and that he would just end up stir crazy. Boy was I wrong!

When I got him home and started training, he knew 'sit' and 'shake' right off the bat! I taught him to go lie down when we are having dinner, to sit and wait for his food until I give him the signal. I thought we were off to a great start, but little did I know that he would soon become my medical alert dog!

Some time later, my son came to me in the middle of the night, acting kind of strangely. I didn't realize it right away, but TatorTot was starting to act strange too. Before I knew it TatorTot was running back and forth between my son and I, barking and whining. I told him to knock it off of course and tried to get him to come lie down with me. Finally after a few minutes I went to check on my son. He was completely unconscious, but not like any other passed out child. TatorTot was still barking and whining and licking my son's face. Any other child surely would have woken up from this! Even when I tried to wake him up he didn't move or flinch. As I scooped my son in my arms, I whispered 'Good boy TatorTot!'

I rushed my son to the hospital, finding out after hours of being there that his glucose levels were dangerously low. We still haven't found the cause, but without TatorTot, I'm not sure my son would even be alive today. I owe all of my gratitude, love, and protection to my pit bull!

—CHRISTI SMITH

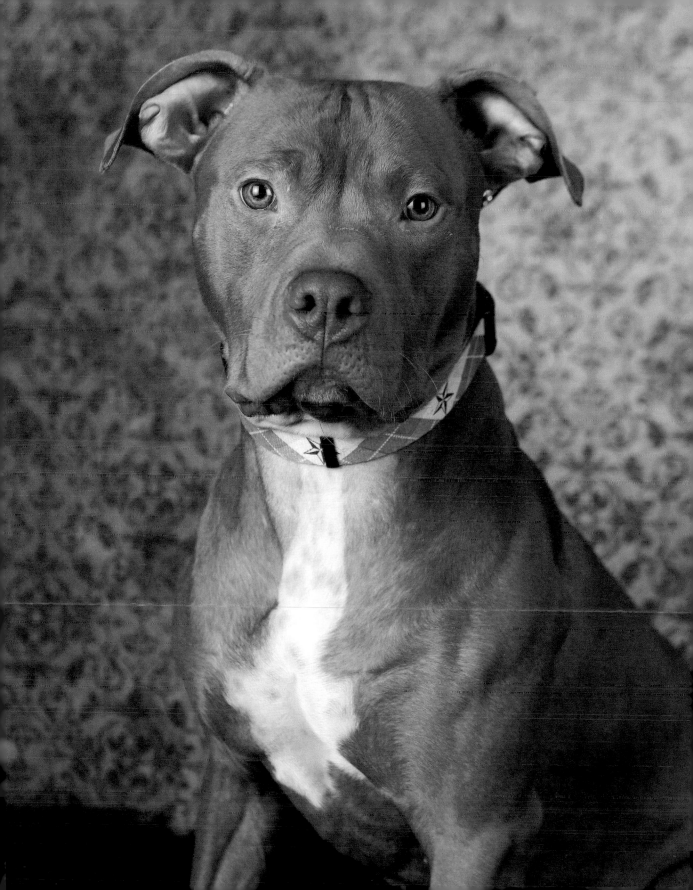

" Handsome Dan is one of the twenty-two dogs who came to Best Friends Animal Society from the estate of NFL quarterback Michael Vick after he was arrested and charged in connection with a dogfighting ring.

He was among the bottom third of the dogs evaluated by Tim Racer, founder of Bad Rap, and Rebecca Huss, court appointed guardian to the dogs. During the initial evaluations Tim granted him his name, thinking Dan needed a confidence boost, so Handsome Dan it was. While Dan was extremely fearful of people, he was great with other dogs and not dangerous at all.

After a year and a half of love and care at Best Friends, Dan was the second dog to be adopted, making his way home to Rhode Island. His learning curve was going to be steep, but both he and his family were up for the challenge. Handsome Dan will likely always be a fearful dog, but has come so far since he was rescued from the Vick compound. The amazing people he has met along the way have shown him that human-kind can offer love and care. "

—HEATHER GUTSHALL, Outbound Hounds and
Handsome Dan's Rescue for Pit Bull Type Dogs

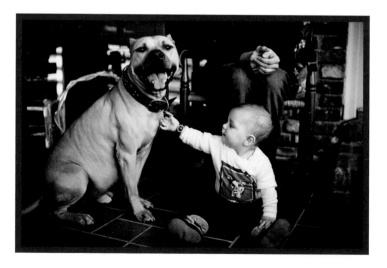

HANDSOME
DAN

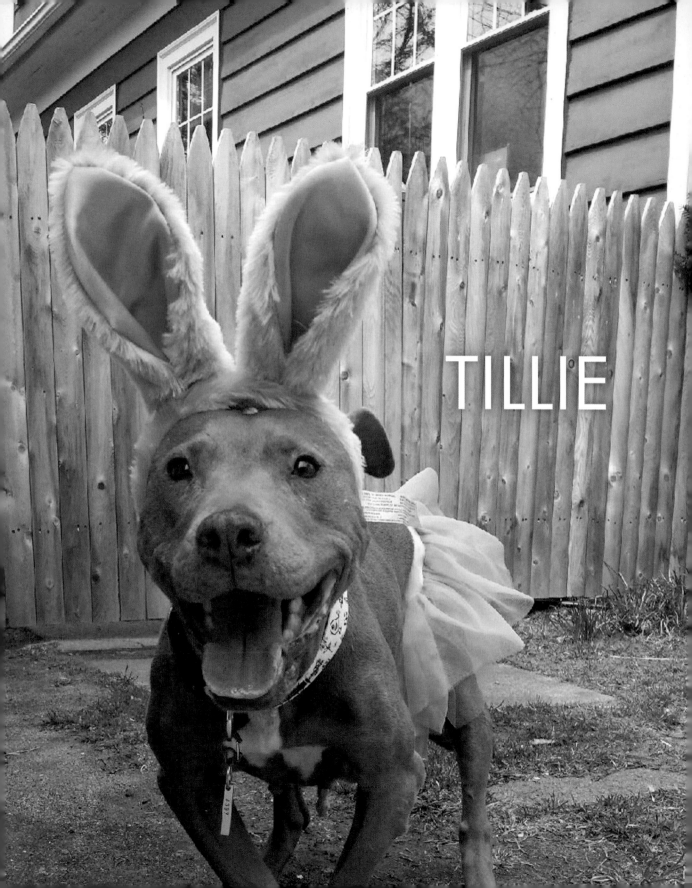

TILLIE

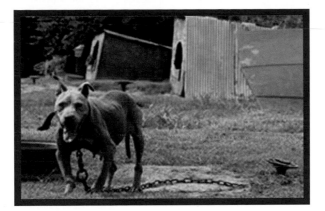

"It was my first day on my first deployment at the temporary facility housing the dogs from a recent dogfighting case. I was nervous and excited and ready to get started. We began cleaning the kennel runs and gradually moved block-by-block. We loaded up our supplies and quickly got to work.

Then, time stopped. I saw her and I froze dead in my tracks. She was lying on a raised bed, her red body old and tired. I could see golf ball–sized tumors running the length of her mammary chain. She struggled to stand, and slowly walked toward me stopping at the gate to her kennel. Her front legs were bowed out; her body broken slowly over years under the weight of her heavy chain. Her face was wise and kind. She was quiet, slow, and searching for acceptance. I knelt down to her. I stroked her face and side through the chain link. I am not sure how long we stayed like that, in complete silence, holding soft eye contact.

After much deliberation, we decided to name the red dog Tillie and over the coming days I would spend any extra time I could sitting on the floor with her. I believe I loved her from the first moment I saw her, that first morning on my first day. As I got to know her over the next few days I grew to love her even more.

Her poor body. Her poor legs. But she acted as if she had no idea why anyone would feel sad for her. It's hard to pity something that won't have it. And that's how it is with Tillie. She is an unbreakable spirit."

—HEATHER GUTSHALL, Outbound Hounds
and Handsome Dan's Rescue for Pit Bull Type Dogs

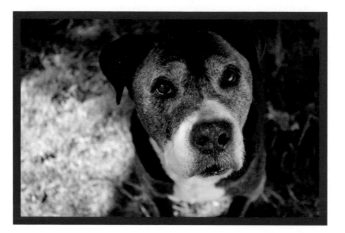

"His name was Mojo, and he changed the world just by being himself. In 2000, Mojo had been found wandering the streets of the Bronx. Those who found him said that he was used as a stud dog by a building superintendent who no longer wanted him. He suffered a broken knee that grew back crooked, a broken jaw and bite scars, but Mojo was such a joyful spirit that those issues were not even immediately noticeable. His personality was bigger than all of it.

We brought Mojo home with us on October 7, 2000, and began our journey together. In many ways, Mojo was a model dog. But as with all pets, some behavior challenges arose, and Mojo challenged us to find kind, effective solutions. Most people walk dogs. Mojo taught us how to walk with dogs. He taught us that you don't need choke chains or intimidation to communicate with animals. Earning trust is what's most important. Mojo inspired us to put those lessons into practice, and in 2005 we opened Urban Dawgs, a positive, reward-based dog training and consulting business.

Mojo loved living near the beach and enjoyed many wonderful, healthy years with us. On April 15, 2014, Mojo passed away from natural causes, peacefully at home in our arms after having had a wonderful play time together just earlier in the day. Despite poor treatment in his early life, he loved everyone and would repeatedly win people over with his warm smile, gentle heart, and comedic antics. Thank you Mojo for blessing us with your divine spirit."

—VYOLET & DRAYTON MICHAELS

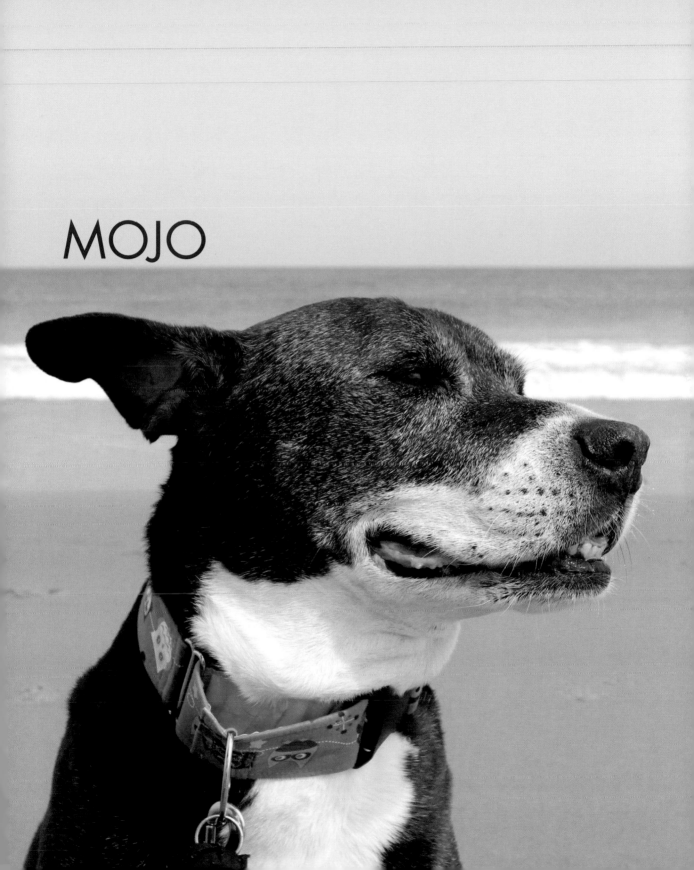

MOJO

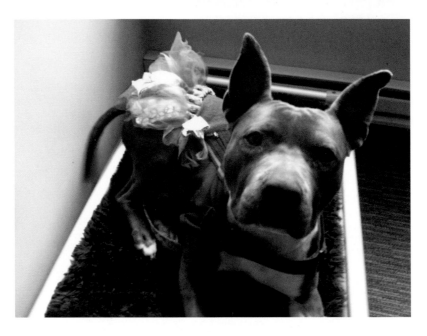

THELMA SPARKLEPANTS

"*Thelma Sparklepants is the fashionista of our Thera-pits group. She has more clothes and tutus than any dog should. But this is partially due to being built like an eighteen-wheeler and people thinking she's a boy when she's doing therapy work. Often she doesn't act very ladylike though; her Facebook page has a daily gas-o-meter rating because she is eternally gassy.*

"*Puddin' Pops was rescued in 2009 from a dogfighting bust in Ohio, which at the time was the second largest bust of its kind in the country. At 10 years of age, he'd been fought and used for stud his entire life, living in a hell few of us can imagine. I spied him on Petfinder shortly after his rescue and was able to adopt him. That was three years ago. He became a therapy dog, inspired me to create a Facebook page called 'Puddin's Pittie Palace.' He was diagnosed with cancer this past spring, but at the same time he was also awarded several honors, one of which was being chosen as a Pinups for Pitbulls 2015 Calendar Dog. To this day, he continues to work as a Thera-pit.*"

—KAY BEARD

PUDDIN' POPS

"Rocco is a very special dog who has overcome a lot to become a helper, friend, teacher, and beloved family member. I rescued Rocco as a small scared puppy after I saw him on Facebook in an urgent listing with his siblings. They were all scheduled to be euthanized based on their breed. When Rocco first came home with us he was afraid, but he soon found comfort in our elder dog Sadie and cat Henry. Rocco went to classes right away, and eventually graduated with a therapy dog certificate. He has worked with children at libraries, helping them to learn to read. Often shy or scared children would gravitate toward Rocco because they saw that Rocco himself was a quiet reserved type and the children felt comfortable with him.

Perhaps, the most important thing that Rocco provides is comfort to me with my illnesses. I had to stop working in 2013, and Rocco has been there for me through all my troubles. In very low times he keeps me going. Trained as my service dog, Rocco helps to retrieve my belongings, carries my things for me, and can lead me to exits or help if I need it. He is very much in sync with me and is always ready to rest when I rest and go when I go. It's as if we are one soul."

—VALERIE WILSON

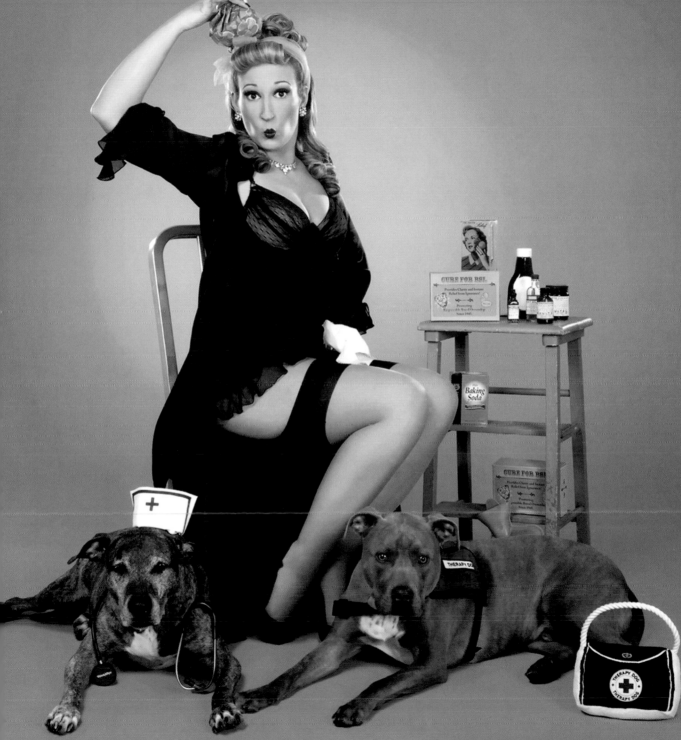

ROCCO

BEHIND THE SCENES

> *"When I first met Deirdre in 2005, we were both beginning our separate journeys in life. She was a saucy burlesque performer who went by the name 'Little Darling' and I was just another photographer in the crowd hoping to capture some great shots of the evening's performance. While we were both dreaming of bigger and better things, neither of us knew that one day we would be building some of those dreams together.*

CELESTE GIULIANO
PHOTOGRAPHY

Busy with our own careers, we both drifted away from the burlesque scene. While Deirdre was furthering her education and starting Pinups for Pitbulls, I was busy building a strong photography business specializing in retro-styled portraits. I had always loved the classic pin-up girls and how lovely they looked in magazines and in calendars so, it was a real treat for me to offer this transformation to everyday girls. Occasionally, I would hear of all the wonderful things Deirdre was doing and how she incorporated the pin-up girl as a way to help raise awareness for bully breeds. Here was a woman who understood how powerful the classic image of a pin-up girl could be and put it to good use, something I greatly admired.

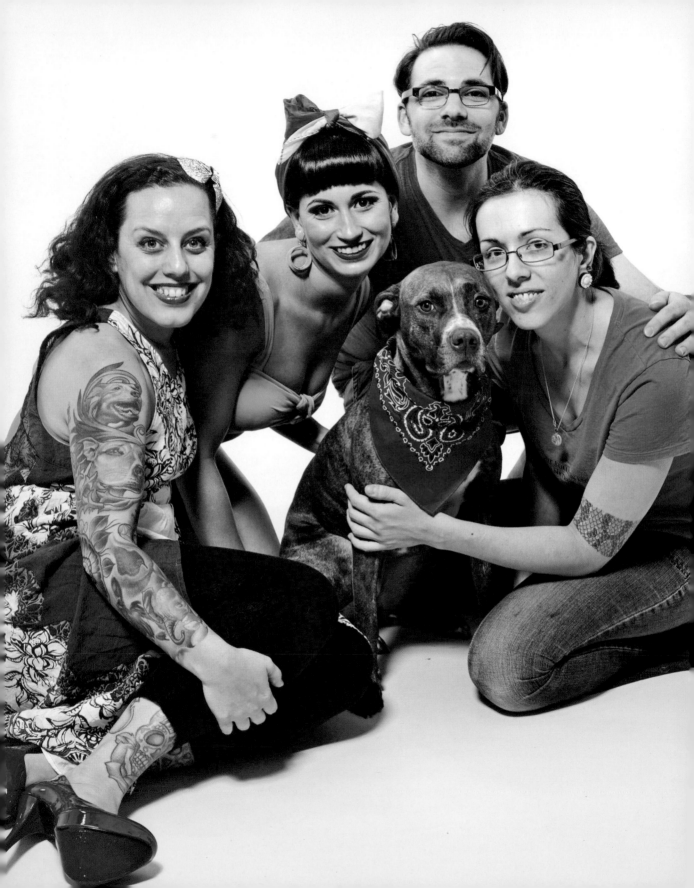

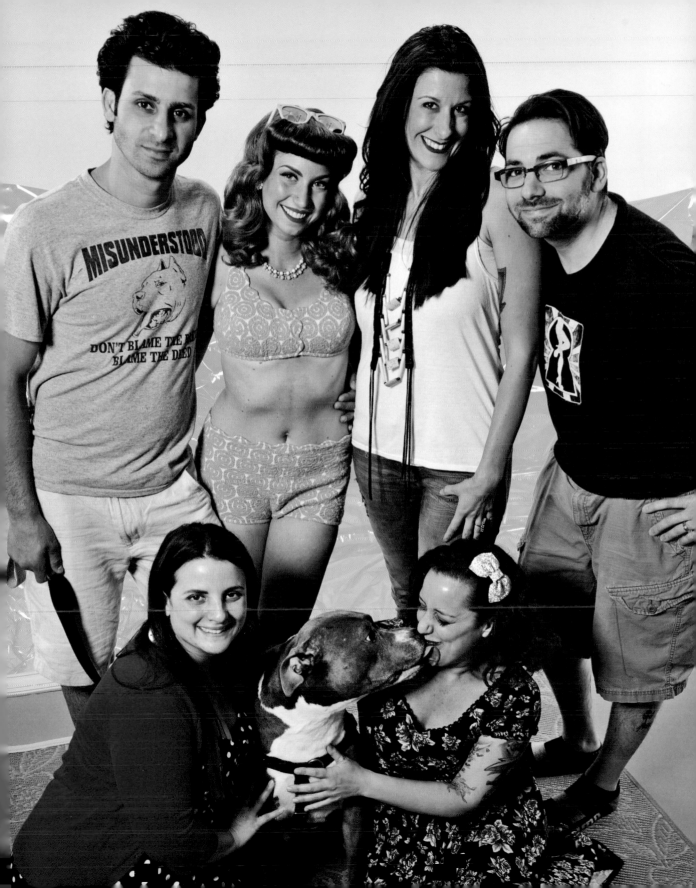

Our paths finally crossed again when we bumped into each other at a flea market in 2008. It was one of those random encounters where you look back and thank Fate for putting us both in the same place at the same time. I had a successful pin-up photography business at that time and Pinups for Pitbulls had gained such a large following that they decided to have open submissions for their annual calendar. Along with the help of Deirdre and Pinups for Pitbulls, I soon had a handful of girls and their canine companions in my studio for pin-up photos. These early days of shooting pups were always full of unexpected surprises and excitement and always ended with lots of kisses and belly rubs.

My photography was featured several times in the calendars over the next few years. In 2011, I photographed the calendar cover and was honored to also be chosen to take Deirdre's 'Founder' page photos for both the 2011 and 2012 calendars. All of this would have been enough for a girl who dreamed of one day seeing her pin-up artwork in a calendar. However, I was then fortunate enough to be asked to photograph and design the entire calendar starting in 2013. So began one of the most amazing and meaningful creative partnerships I could have ever asked for!

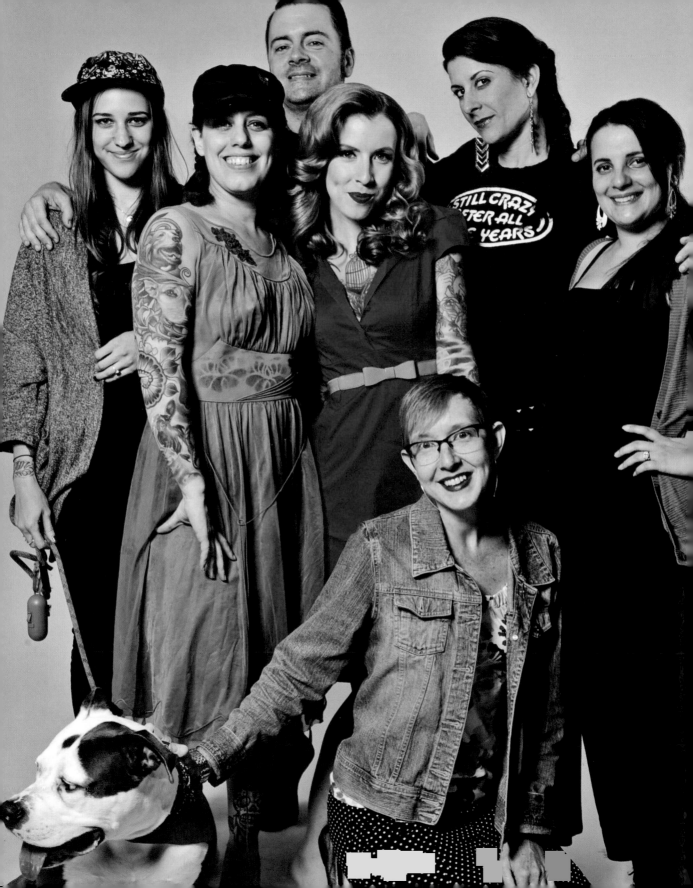

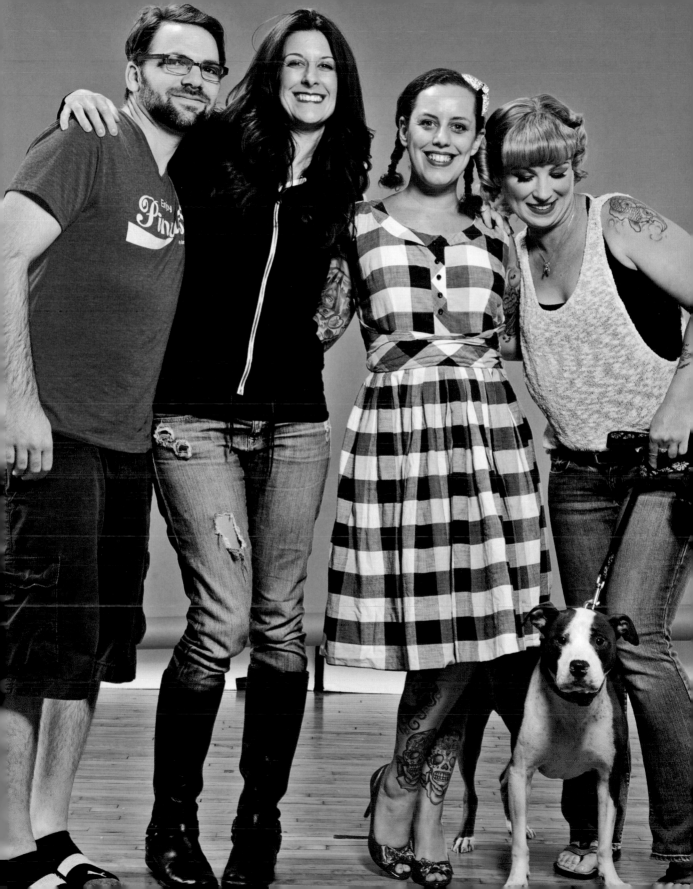

I consider myself very fortunate to be able to make a living doing what I love, but it is even better when you have the opportunity to do that alongside your friends. Working with Pinups for Pitbulls and photographing their calendar has taught me that. My husband David—an illustrator by trade—will sit down and brainstorm themes and ideas with me months before the calendar girls are even selected. We will spend nights at auctions and weekends at flea markets looking for those perfect props to tell our story. During our shoot days, my talented stylist Raina magically transforms our girls into perfect pin-ups, David runs around making sure every set detail is in place, Deirdre and her husband Jeff help coax the dogs with treats and get them into position while I compose the scene and snap away for that perfect calendar shot. The studio oftentimes resembles a madcap scene from a 1950s screwball comedy, but one that has assembled the best cast ever.

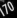

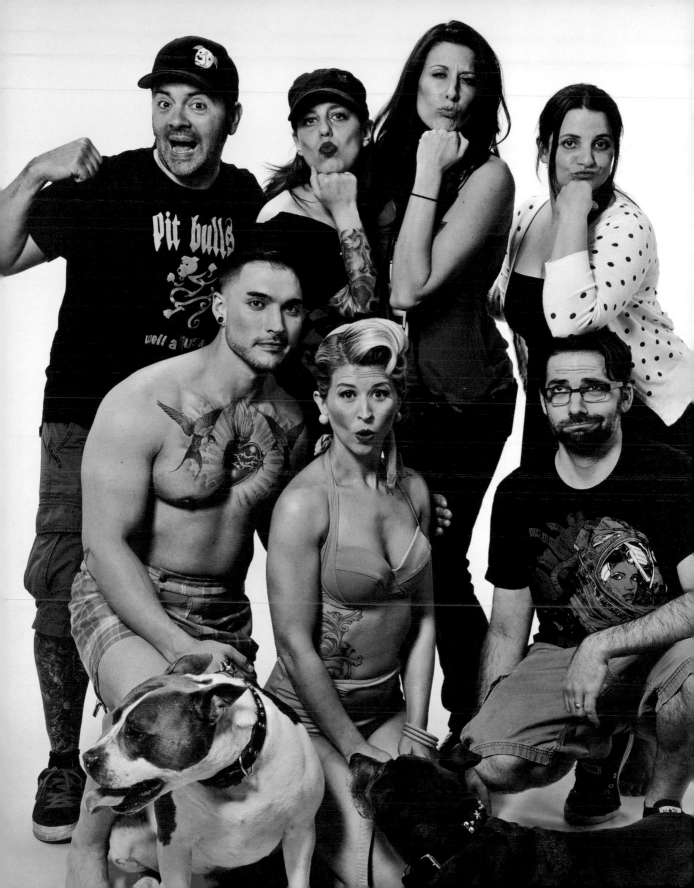

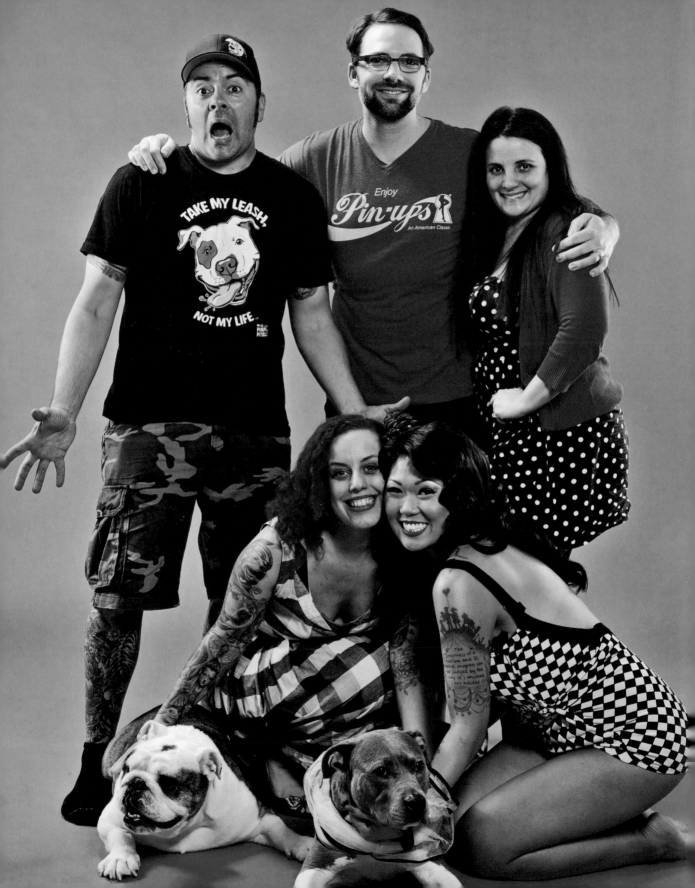

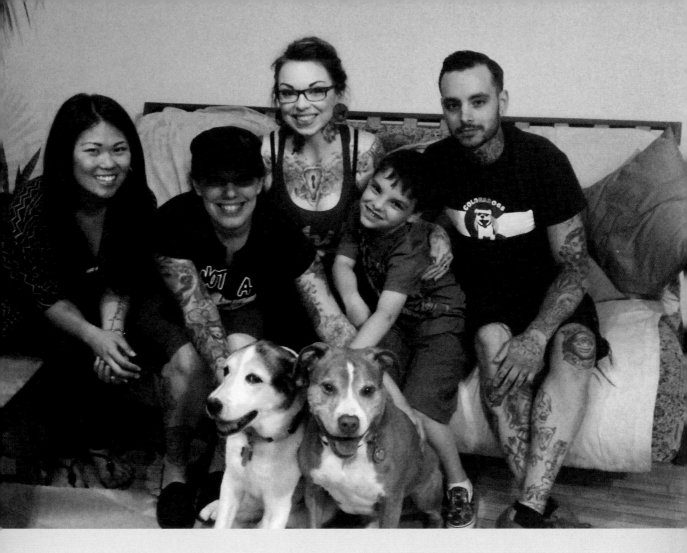

There is something to be said about the value of a great relationship. I have done my best to capture the loving connection between a girl and her dog in each of my photos. I rely on the strong, healthy relationships I have with the people I work alongside in my studio. I see the supportive relationships between all of the volunteers and models who work with Pinups for Pitbulls. This entire journey has made me value even more the friendship that I almost missed all of those years ago. The one with that saucy burlesque performer called Little Darling."

—CELESTE GIULIANO

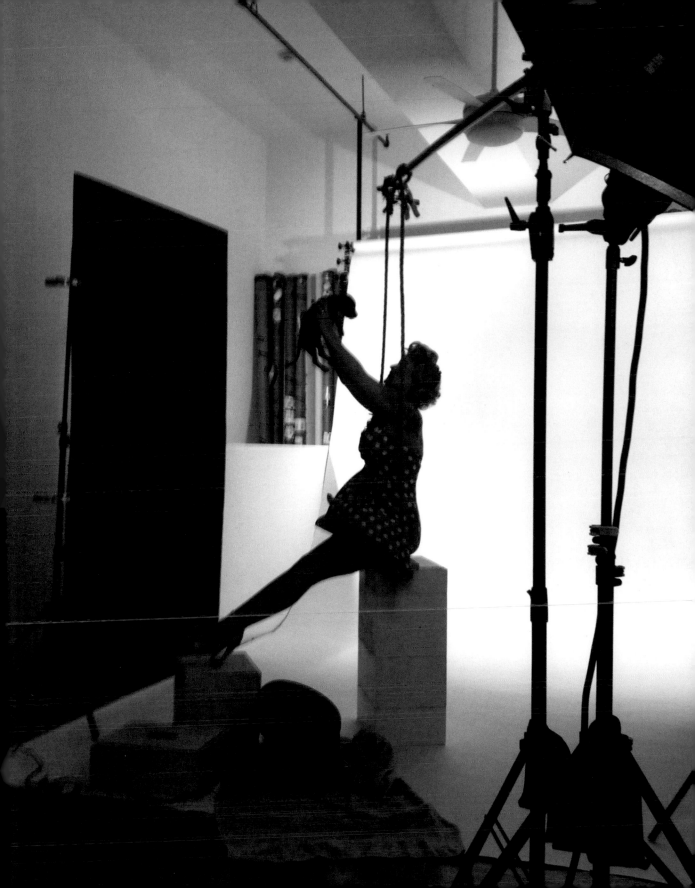

"An editor's job usually calls for staying behind the scenes, quietly guiding a book from manuscript to page proofs to finished product. So when Deirdre asked me to pose for a few shots, I was initially hesitant. But the idea of featuring my dog Charlie in the book he helped inspire was impossible to pass up. Charlie came to me through a foster network in Brooklyn. I knew next to nothing about pit bulls at the time, but when I saw Charlie's smiling face on Petfinder I knew I'd found a friend. Abandoned on the streets of New York City as a puppy, he latched onto me from the moment we met, bowling me over with his surprisingly strong frame and furiously licking my face. (He often still does this when I come home from work, eight years later!) He was quite a handful as a puppy, but never showed the slightest bit of aggression. He opened my eyes to the issues facing dogs like him—unfairly targeted because of their "breed"—and he inspired me to get active in the rescue community.

I grew up in the Philadelphia suburbs, so when I heard about an organization based near my hometown with the curious name of Pinups for Pitbulls, I instantly wanted to meet the person behind it. I reached out to Deirdre about writing a history of pit bulls in America, but when we started talking about the organization she built from the ground up and the dedicated volunteers and supporters around the country, the book I thought I wanted to publish became the book you now hold in your hands."

—DAN CRISSMAN,
Senior Editor, The Overlook Press

2015
A SNEAK PEEK!

The theme is loosely fitted around Archie comics and other comic book-style colors. We had so much fun making the 2014 calendar that we wanted to step up the creative levels of our output even more. Working with Celeste, David, and Raina is truly like a dream. We have so much fun together on set and off. The past three years working with them has truly helped our mission grow exponentially. The quality of their work and the comprehension that they have of what we are trying to put out to the world is unmatched.

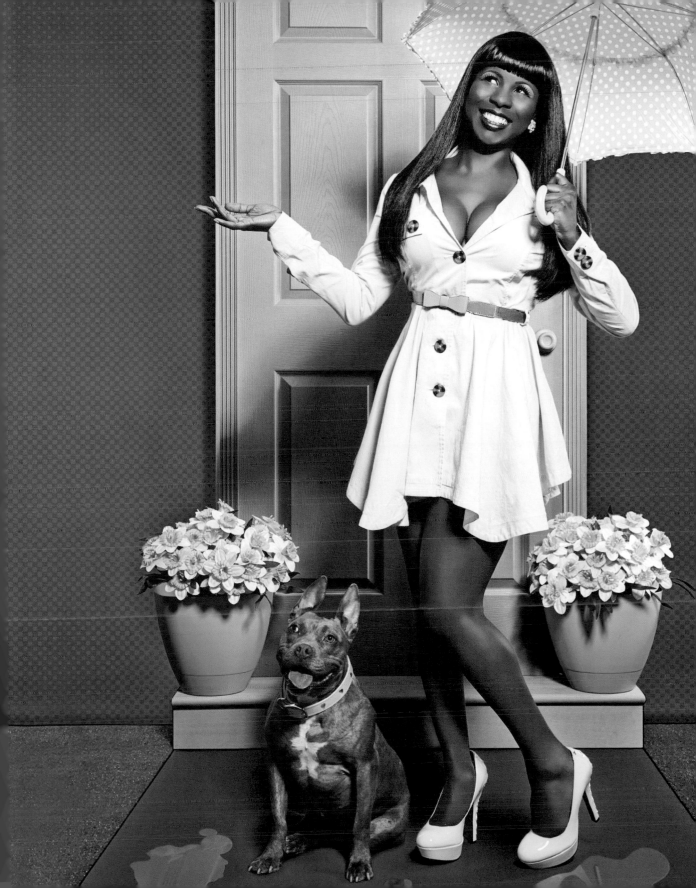

ACKNOWLEDGMENTS

I am so full of gratitude toward everyone who has purchased this book, passed it along to a friend, and taken the time to read it. Without the following people, this project might not have taken place.

First and foremost, thank you to Dan Crissman and your beloved dog Charlie for choosing our story to share with the world. We could not have made this book what it is without the two of you. Thank you to the entire team at The Overlook Press for believing in our message and our efforts, especially Peter Mayer, Kait Heacock, Jill Lichtenstadter, Jack Lamplough, and Anthony Morais.

Thank you to my adoring husband, Jeffrey for always having my back, even when I wasn't sure if I could stand. You were there when Carla Lou passed and you helped me shift through the grief along with Baxter Bean, Zoe, and the now-late Lexi. Your fierce defense of this mission of mine has become your own. I am in awe of your dedication and am better for it.

I am forever grateful for Celeste Giuliano, David Seidman, and Raina Clarke for your incredible composition in our annual calendar project. Thank you to all of the photographers and hair and make-up teams that have allowed us to share your photographs from our past calendar years. We have always been a work in progress and have been so lucky to have such amazing talent in the forms of art and as models/volunteers to help further our cause.

Thank you to our board members for awarding us with the necessary tools to finish this project. Special thanks to Rachel Robison, Doron Petersan, Sandy Jones, Jen O'Donnell, and Nancy Sklencar for moving this growing ship along year after year. Deepest thanks to Stacey Conant for flying to Asheville to help me with this project and for being my right hand throughout the process.

Thank you to Fred Kray and the entire Pit Bulletin Legal News Network for giving me a voice every Tuesday on your radio show, and a special thanks to Kris Diaz of StopBSL.org for keeping me abreast of all BSL-related developments. I am especially grateful to Katie and Anthony Barnett for their immense assistance in my case study research which served as a jumping off point for this book.

Thank you also to Sarah Mikulski, Jeffrey Loncosky and Kristen Greger for helping with proofreading my entire case study that helped fuel this book. Thanks to my parents, Alan and Joy for teaching me about non-profit work and grassroots advocacy.

Thank you to the Pinups for Pitbulls, Inc. family of hardworking, dedicated advocates. You are all responsible for our mission moving forward. You are truly the backbone of our success. Thank you to everyone who contributed images or artwork for these pages and for those of you who have applied to be a part of our calendar each year, on two, three, or four legs. Thank you to Unique Vintage for sponsoring our past two calendars and outfitting our girls with a beautiful wardrobe. Thank you to everyone who has ever donated to our mission purchased our merchandise, or shared a dog in need through our network.

Additional thanks to Jessica Berndt, Tabatha Acosta, Jennifer Corona, Amanda Little, Rob Paluso, Nancy Ettleman and The General Design Co.

Thank you to all of the people that work in rescue, volunteer, train/behavior modify with positive reinforcement, educate, research, and push to advance our cause. We are each one piece of this macrocosm of advocacy work. We will not stop until we put ourselves out of business by eradicating breed-specific legislation once and for all. We can only achieve this as a community that works together.

CREDITS

CELESTE GIULIANO PHOTOGRAPHY:

Blair Barbour and Romeo (adoptable through Molly's Place Animal Rescue), p. 2

Deirdre "Little Darling" Franklin and Baxter Bean, p.3

Anahita Dua and Xena By (Dog parent: Sherry Stinson), p. 4

Stephanie Olson and Echo Tango-Foxtrot (Dog parent: Nycholle Eckert), p. 7

Jenna Yenik and Honey Bee (Dog parents: Melissa DeRobertis and John Teague), p. 8

Erin Earley-Hamilton and Pacino, p. 11

Sherri Wonderland and Shyla, p. 12

Stacey Lea, Thunder, and Taylor (Dog parent: Chris Marrone), p. 13

Deirdre Franklin and Carla Lou, p. 15

Carla Lou Outtakes, pp. 16–18

Deirdre Franklin and Carla Lou, p. 26–27

Reita Nairn, Zelda, and Gunnar, p. 52

Nicole Tassinaro and Jenks, p. 54

Deirdre Franklin, Carla Lou, and Baxter Bean, p. 64

Brook Bolen and Emma (Dog parent: John Franklin), p. 66

Laura Chavarria and Klyde, p. 67

Kira Ikeda and Pike, p. 68

Jennifer O'Donnell and Tank, p. 69

Stephanie Borden, Luna, and Butchie (Dog parent of Butchie: Joe Costello), p. 70

Lisa Carolla and Primo, p. 71

Celeste Giuliano, Baxter Bean, Jeffrey Loncosky, Raina Clarke, Deirdre Franklin, and David Seidman, p. 72

Amanda Moore and Cuda (Dog parent: Julie LeRoy), p. 73

Nancy Sue Sklencar and Brock, p. 74

Anne Mi Bosse and "G" DePaul (Dog parent: Andrea Vitelli), p. 75

Meredith Hammock and Harlow, p. 76

Dahlia D. and Batman (Dog parents: Kirsten & Matthew Greskiewicz), p. 77

Shelley Milburn and Porter (Dog sponsored by Pinups for Pitbulls, Inc. for Street Tails Rescue), p. 91

Rachel "Love" Robison and Itty Bitty, p. 92

Sandy "Sandra Dee" Jones, David Seidman and Ruby Lu, p. 95

Doron Petersan and Lucas, p. 97

Deirdre Franklin, Jeffrey Loncosky, and Baxter Bean, p. 99

Katie Bray Barnett and Ahab (Dog sponsored by Pinups for Pitbulls, Inc. for Street Tails Rescue), p. 104

Deirdre Franklin, Carla Lou, and Baxter Bean, p. 111

Deirdre Franklin and Carla Lou (Photographer actors: Stephanie Borden and Rob Paluso), p. 121

Deirdre Franklin and Leonidas the Brave (Art by Paul Palcko), p. 126

Sadie, Rocco, and Valerie Wilson, pp. 152–153

Blair Barbour, Romeo (adoptable through Molly's Place Animal Rescue), and David Seidman, p. 155

David Seidman, Raina Clarke, Stephanie Olson, Nycholle & Echo Eckert, and Deirdre Franklin, p. 156

Jonathan, Sarah and Griffin Seibold with Raina Clarke, Deirdre Franklin, David Seidman, and Celeste Giuliano, p. 157

David Seidman and Porter (Pinups for Pitbulls sponsored Porter for Street Tails Rescue), p. 158

Deirdre Franklin, Rachel Yarger, David Seidman, Kris Diaz, and Juno Z. Dog, p. 160

Angie Mongelli and Romeo of Romeo's Paws For a Cause, Michael Mongelli, Raina Clarke, David Seidman, Celeste Giuliano, and Deirdre Franklin, p. 161

Raina Clarke, Tara Metzler and Stella, David Seidman, Celeste Giuliano, Jeffrey Loncosky and Deirdre Franklin, p. 164

Raina Clarke, Jeffrey Loncosky, Maggie & Emmett Marton, David Seidman, Deirdre Franklin, and Celeste Giuliano, p. 165

Deirdre Franklin and Baxter Bean, p. 166

Lauren & Morty Perlstein, Deirdre Franklin, Jeffrey Loncosky, Hannah Shaw, Nancy Sklencar, Raina Clarke, and Celeste Giuliano, p. 168

David Seidman, Raina Clarke, Deirdre Franklin, Emily Ugarenko, and Daphne, p. 169

Jeffrey Loncosky, Deirdre Franklin, Raina Clarke, Celeste Giuliano, Matthew, Batman, Minka & Kirsten Greskiewicz, and David Seidman, p. 171

Jeffrey Loncosky, Deirdre Franklin, David Seidman, Celeste Giuliano, Michelle, Queenie, and Biggie Choi, p. 172

Raina Clarke, Jeffrey Loncosky, Kristen Greger, Celeste Giuliano, David Seidman, Deirdre Franklin, Kay Beard with Puddin' Pops, p. 173

Dan Crissman and Charlie, p. 176

David Seidman, Celeste Giuliano, Jeffrey Loncosky, Dan Crissman, Charlie, Deirdre Franklin, and Raina Clarke, p. 177

Dawn Taylor and Lexi, p. 179

WANDERING BOHEMIAN PHOTOGRAPHY:

Deirdre "Little Darling" Franklin and Carla Lou, p. 19

Deirdre Franklin and Carla Lou, p. 20

Deirdre Franklin and Baxter Bean, and Carla Lou, p. 30

Sandy "Sandra Dee" Jones and Ruby Lu, p. 34–35

Sandy Jones, Stella, and Jema (Dog parent of Jema: Erin Doody), p. 56

Zoe, Carla Lou, Deirdre Franklin, Baxter Bean, and Lexi Doodle, p. 83

Jennifer Berke and Oogy by Wandering Bohemian Photography, p. 133

182

OTHER PHOTOGRAPHY:

WEBSITES

- Pinups for Pitbulls Inc.: www.pinupsforpitbulls.org

- Pit Bulletin Legal News Network: www.PBLNN.com

- National Canine Research Council: www.nationalcanineresearchcouncil.com

- *Beyond the Myth* (film): www.beyondthemythmovie.com

- Karen Delise's *Pit Bull Placebo* (free download): http://nationalcanineresearchcouncil.com/publications/ncrc-publications/

- Stop BSL: www.stopbsl.org

- KC Dog Blog: www.btoellner.typepad.com/kcdogblog/

- Game Dog Guardian: www.gamedogguardian.com

- Up the Pups: www.upthepups.com

- Pit Bull Guru: www.pitbullguru.com

RECOMMENDED READING

Bradley, J. (2005). *Dogs Bite: But Balloons and Slippers are more Dangerous.*
James & Kenneth, Berkeley.

Capp, Dawn. *America's Discarded Dog: The Pit Bull.* Charleston: Dawn Capp, 2013.

Lahart, M. (2009). "Defending Allegedly Dangerous Dogs: The Florida Experience." In
J. Schaffner (Ed.), *A Lawyer's Guide to Dangerous Dog Issues* (pages 61-71).
Chicago: American Bar Association Publishing.

Patronek, et al. (2010). "Exploring the Bond: Use of a number-needed-to-ban calculation to
illustrate limitations of breed-specific legislation in decreasing the risk of dog bite-
related injury."*Journal of the American Veterinary Medical Association*, 237:7,
788–792.

Shapiro, Kenneth J. (2008). *Human-Animal Studies. Growing the Field,*
Applying the Field. Animals & Society Institute.

Stone, D. (2012). *Policy Paradox: The Art of Political Decision Making.*
(3rd ed.). New York, NY: W.W. Norton & Company, Inc.

Welch, M. (2009). "Prosecuting Dangerous Dog Cases." In J. Schaffner (Ed.),
A Lawyer's Guide to Dangerous Dog Issues (pages 39–59).
Chicago: American Bar Association Publishing.

"Potentially Preventable Husbandry Factors Co-occur in Most Dog Bite-Related Fatalities":
http://www.nationalcanineresearchcouncil.com/blog/potentially-preventable-hus-
bandry-factors-co-occur-in-most-dog-bite-related-fatalities/?doing_wp_cron=14006024
78.1266999244689941406250

RECOMMENDED READING

Bradley, J. (2005). *Dogs Bite: But Balloons and Slippers are more Dangerous.*
 James & Kenneth, Berkeley.

Capp, Dawn. *America's Discarded Dog: The Pit Bull.* Charleston: Dawn Capp, 2013.

Lahart, M. (2009). "Defending Allegedly Dangerous Dogs: The Florida Experience." In
 J. Schaffner (Ed.), *A Lawyer's Guide to Dangerous Dog Issues* (pages 61-71).
 Chicago: American Bar Association Publishing.

Patronek, et al. (2010). "Exploring the Bond: Use of a number-needed-to-ban calculation to
 illustrate limitations of breed-specific legislation in decreasing the risk of dog bite-
 related injury."*Journal of the American Veterinary Medical Association*, 237:7,
 788–792.

Shapiro, Kenneth J. (2008). *Human-Animal Studies: Growing the Field,
 Applying the Field.* Animals & Society Institute.

Stone, D. (2012). *Policy Paradox: The Art of Political Decision Making.*
 (3rd ed.). New York, NY: W.W. Norton & Company, Inc.

Welch, M. (2009). "Prosecuting Dangerous Dog Cases." In J. Schaffner (Ed.),
 A Lawyer's Guide to Dangerous Dog Issues (pages 39–59).
 Chicago: American Bar Association Publishing.

"Potentially Preventable Husbandry Factors Co-occur in Most Dog Bite-Related Fatalities":
 http://www.nationalcanineresearchcouncil.com/blog/potentially-preventable-hus-
 bandry-factors-co-occur-in-most-dog-bite-related-fatalities/?doing_wp_cron=14006024
 78.12669992446899941406250